NORTHERN LIGHTS

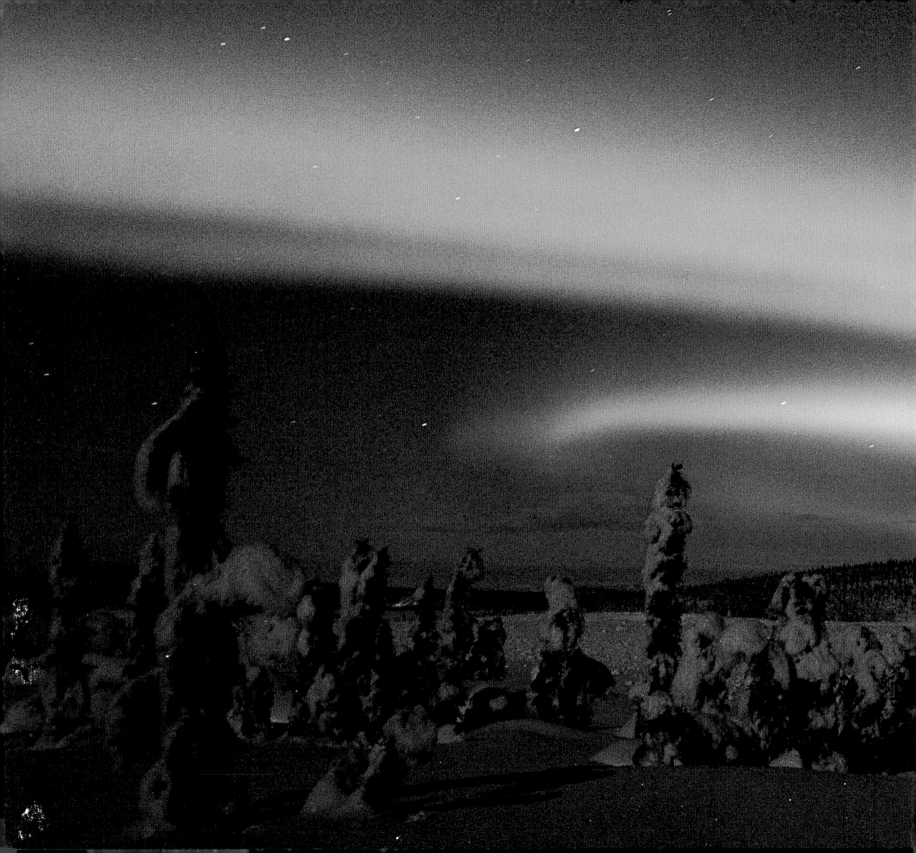

NORTHERN LIGHTS

THE SCIENCE,
MYTH, AND WONDER OF
AURORA BOREALIS

PHOTOGRAPHY BY CALVIN HALL AND DARYL PEDERSON

ESSAY BY GEORGE BRYSON

SASQUATCH BOOKS
SEATTLE

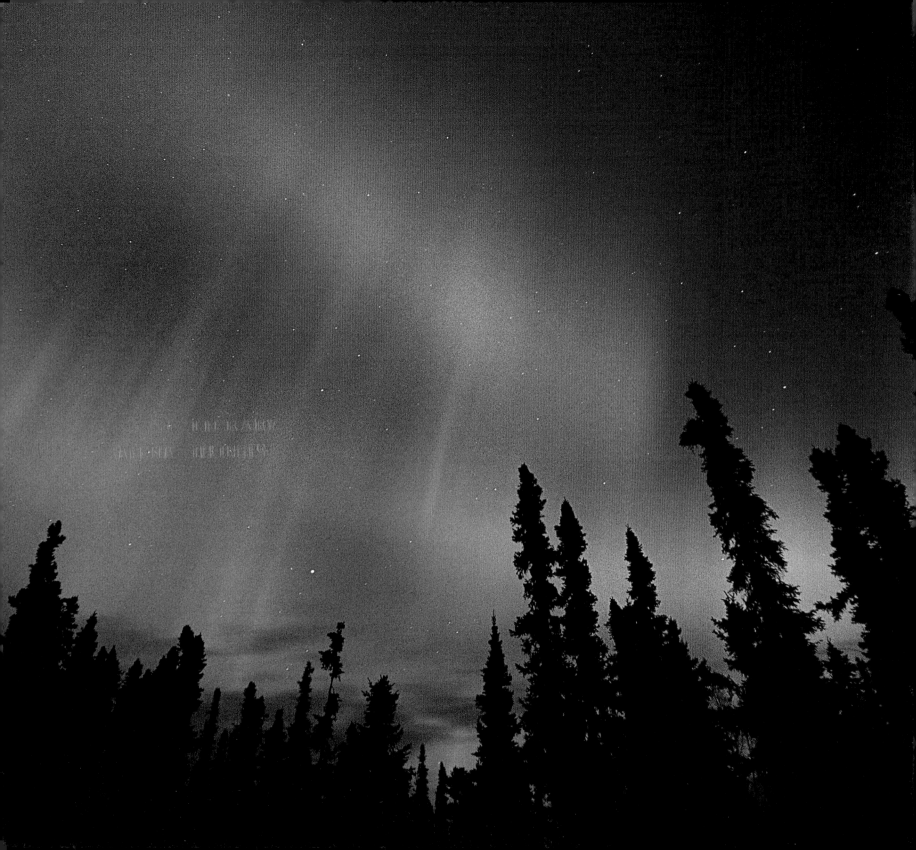

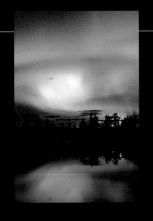

THE NIGHT THE SKY FELL

One hundred years after the fabled Klondike gold rush of '98,

a great aurora began dancing over the Alaska Range. The date was November 7, 1998. In Healy,

Alaska, about seventy-five miles northeast of Mount McKinley, someone standing in the snow outside

a log cabin café pounded on the window and pointed to the sky. Science writer Ned Rozell of

Fairbanks set down his cheeseburger and stepped outdoors to see what the stranger was intent

on sharing—and then he saw it: a rare purple aurora flowing like a river overhead.

"Soon the entire restaurant staff and I were shivering outside," Rozell later wrote. "Even the sourdoughs who'd seen hundreds of displays started whooping. This was no ordinary aurora."

About 125 miles south of McKinley, residents of Anchorage saw the aurora too. First it appeared as a giant curtain connecting the Chugach Mountains to the east with a distant horizon of active volcanoes to the west. Then the curtain began to ripple. Then it seemed to skip around from one place to the next, tossing Technicolor rays at the watchers below.

PREVIOUS PAGE: *This aurora was photographed north of Willow on April 6, 2000, shortly after midnight.*

BELOW: *A rising full moon illuminates Mount McKinley during the major solar storm of November 7, 1998.*

RIGHT: *Hale-Bopp Comet is visible on a moonless night near Montana Creek, in the Talkeetna area (March 2, 1997). Mount McKinley was not actually in view until the aurora silhouetted it.*

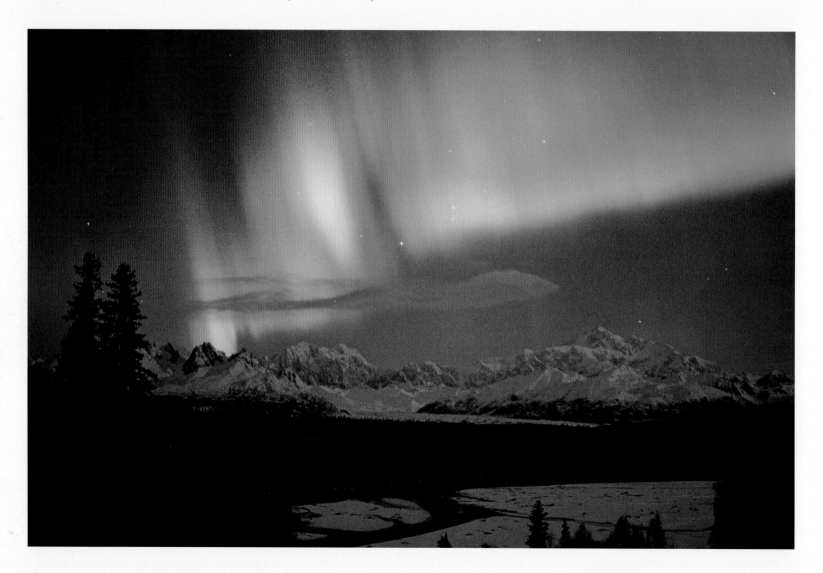

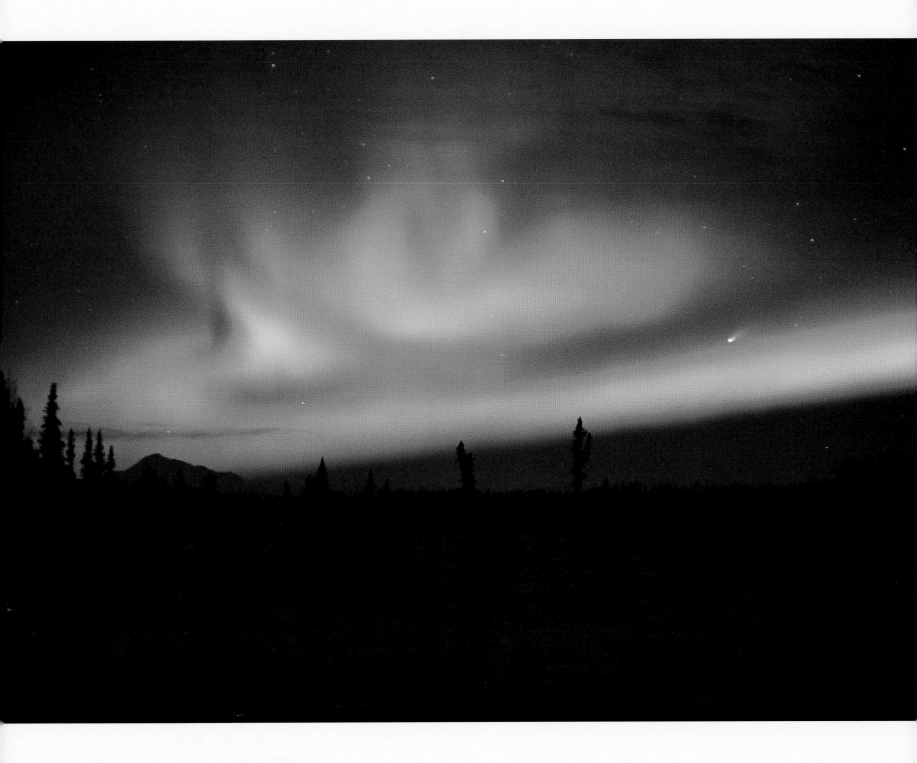

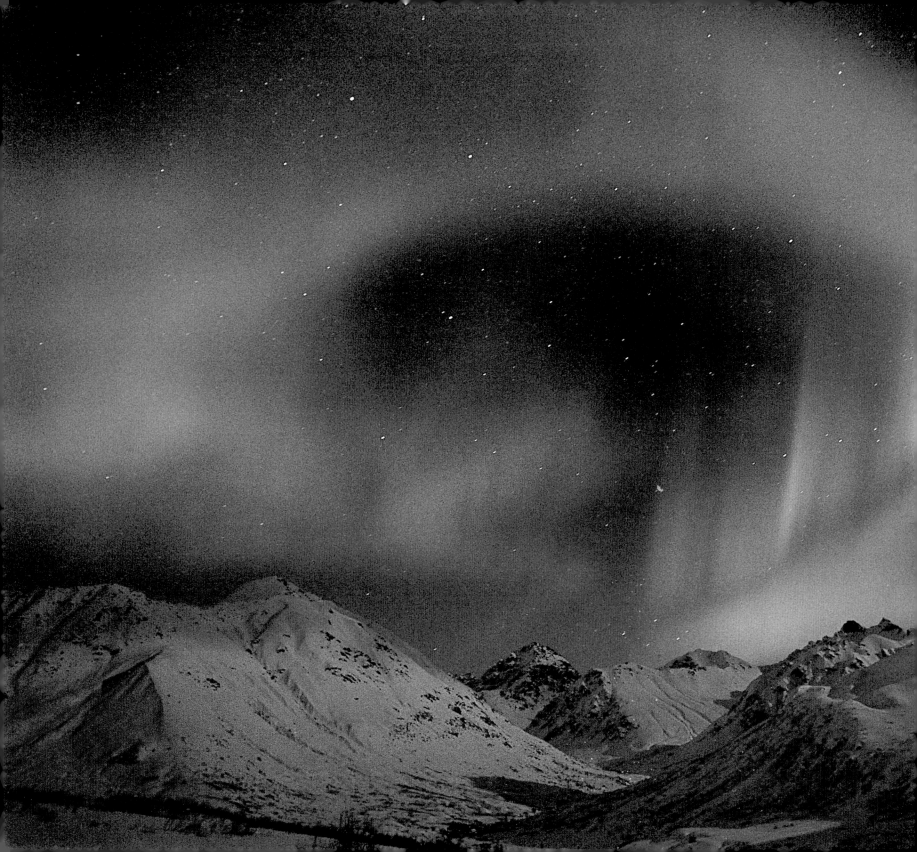

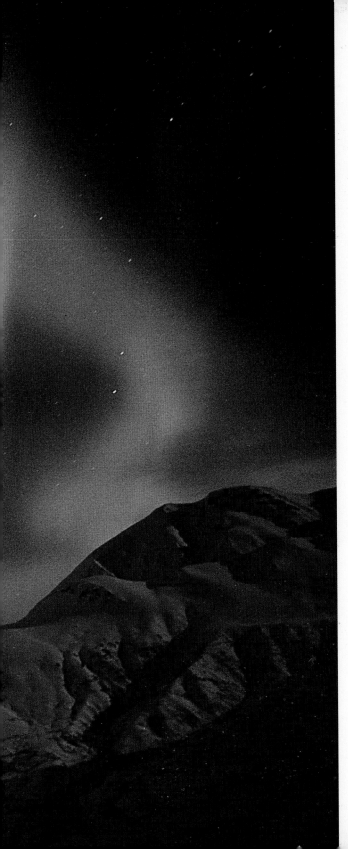

"Oooooh!" murmured voices in the crowd that had begun to assemble along an ocean bluff at Earthquake Park. Some of the people climbed on top of their cars to get a better view. "Ahhhhh!" they cried, as the lights pulsed from green to yellow to pink.

Walking toward my barn in a mountain valley fifteen miles to the southeast, I watched the colors shine even brighter beyond the lights of town. I saw them race across the darkness, eclipsing the stars. For a long while I forgot all about my chores and obligations and simply stared at the flashing sky.

Scientists tell us that the northern lights—the aurora borealis—are always present in the far north, even when we can't see them due to daylight or cloud cover. Usually they remain withdrawn inside the auroral zone, a vertical corridor that encircles the Northern Hemisphere along an oval track about a thousand miles from the magnetic North Pole. (Because the magnetic North Pole is located in the Canadian Arctic about 800 miles south of the geographic North Pole, the northern lights are much more visible in Canada and Alaska than in Europe or Asia.)

When this auroral oval is relatively calm, its centerline transects the northern third of Alaska almost directly above the Arctic village of Fort Yukon. On dark, cloudless, winter nights in Fort Yukon, the chances of observing the northern lights are virtually 100 percent. In Fairbanks, about 125 miles south of Fort Yukon, the odds under the same conditions are around 80 percent. In Anchorage, still farther south, they dip to 40 percent, in Ketchikan to 20 percent, in Seattle to 5 percent, in San Francisco to 1 percent. (A viewing probability of 1 percent means that it's possible to glimpse an aurora three or four nights a year, provided the view isn't obscured by clouds, light, or air pollution.)

It's possible because every so often the solar wind—the ionized gas exhaled by the Sun that powers the aurora—increases in speed and density. As it does, the solar particles excite the Earth's magnetic field in a way that causes the circumference of the auroral oval to expand and slip southward toward the equator. Aurora researchers liken the phenomenon to an expanding halo slipping down the "head" of the globe. Small increases in geomagnetic activity can easily propel the aurora as far south as Anchorage or Whitehorse; larger increases can send it racing toward Vancouver, British Columbia or St. Paul, Minnesota.

Which is just what occurred on that early November night as the world

It was a mild night—10° Fahrenheit—at Hatcher Pass in the Talkeetna Mountains, when this active aurora appeared as an "omega" shape several times (February 23, 2000).

revolved a little closer toward a new millennium. Sky watchers in Alaska saw much more color in the aurora than usual, and northern light shows more typical of Anchorage extended far to the south, treating residents of Seattle and Albany to spectacular displays.

★ ★

Alaskan photographer Daryl Pederson may have had the best vantage point of all: standing on a lonely roadside ledge halfway between Fairbanks and Anchorage and facing the highest mountain in North America. For once, everything was out. The mountain. The stars. The moon. And the most brilliant aurora Pederson had ever seen.

"The toughest part was trying to figure out which way to aim your camera," he said. "You'd look one direction and it was solid red. You'd look another direction and you had five bands of just unbelievable green. You had McKinley sitting in front of you well-moonlit, but you'd already shot a hundred pictures of that—so which way are you going to turn the camera? . . . It was phenomenal."

LEFT: *The aurora this night (November 5, 2000) near Sheep Mountain started out blood red as early as 9:00 pm. Two hours later the last of the red was fading.*

RIGHT: *Two perspectives on the colors of fall (early October) in Southcentral Alaska.*

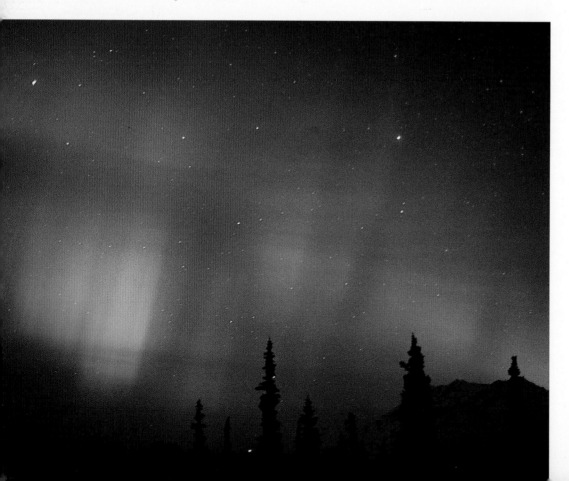

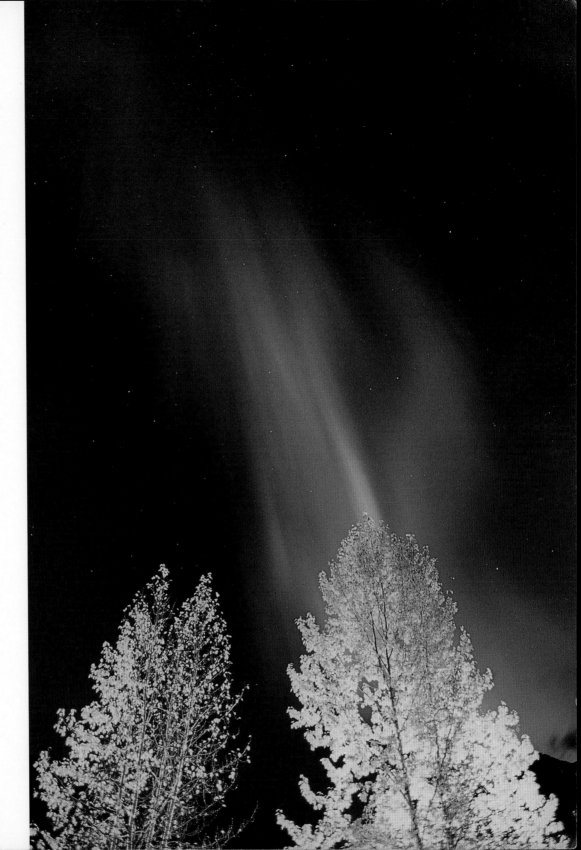

SMALL INCREASES IN
GEOMAGNETIC ACTIVITY CAN
EASILY PROPEL THE AURORA AS
FAR SOUTH AS ANCHORAGE OR WHITE-
HORSE; LARGER INCREASES CAN SEND IT
RACING TOWARD
VANCOUVER, BRITISH COLUMBIA OR
ST. PAUL, MINNESOTA.

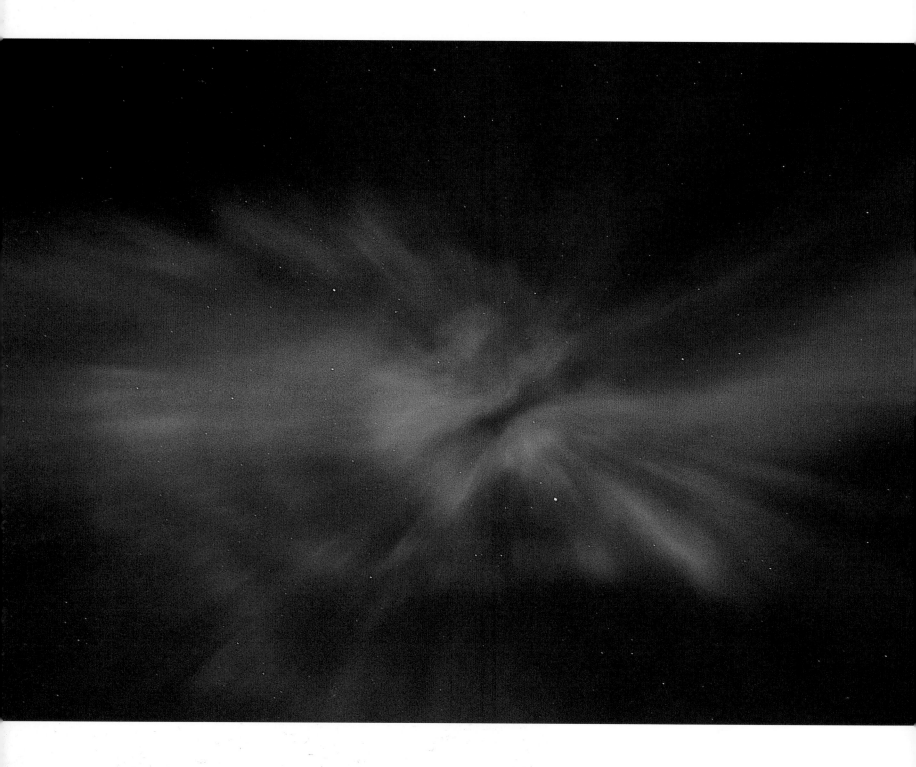

The combination of moonlight and twilight made for a rich blue and pastel display of this unusually early and powerful aurora in the Placer River Valley (August 12–13, 2000). The corona image (LEFT) was achieved by looking directly overhead into the auroral curtain. The moon (RIGHT) was low and partly subdued by high clouds, so it looked like a setting sun.

LEFT: *Pink light hangs over the Peters Hills during this 5:00 am display (November).*

RIGHT: *Although it was cloudy from Homer to Fairbanks, the aurora indicators on the Internet this particular night were high, and an early sighting report came in from central California—making a long trip through fog, freezing rain, and heavy snow a virtual certainty! In fact, this aurora, photographed between cloud and storm breaks 110 miles from Anchorage over the southeast side of King Mountain, was triggered by the largest sunspot in ten years and was seen as far south as northern Mexico (March 30, 2000).*

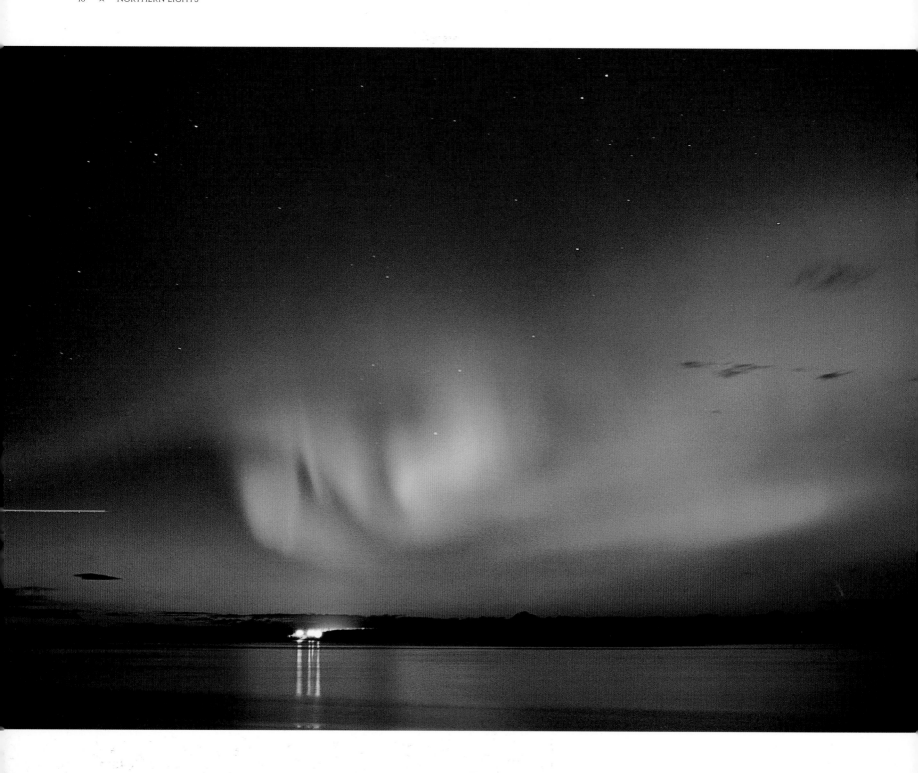

LEFT: *This sunset aurora was visible from Anchorage's Point Woronzof (early September). Note that at this high latitude, twilight can last as long as two hours after sunset or before sunrise.*

RIGHT: *A blast of aurora light can provide enough illumination to read, although measurements conclude that even the brightest aurora is still less intense than full moonlight.*

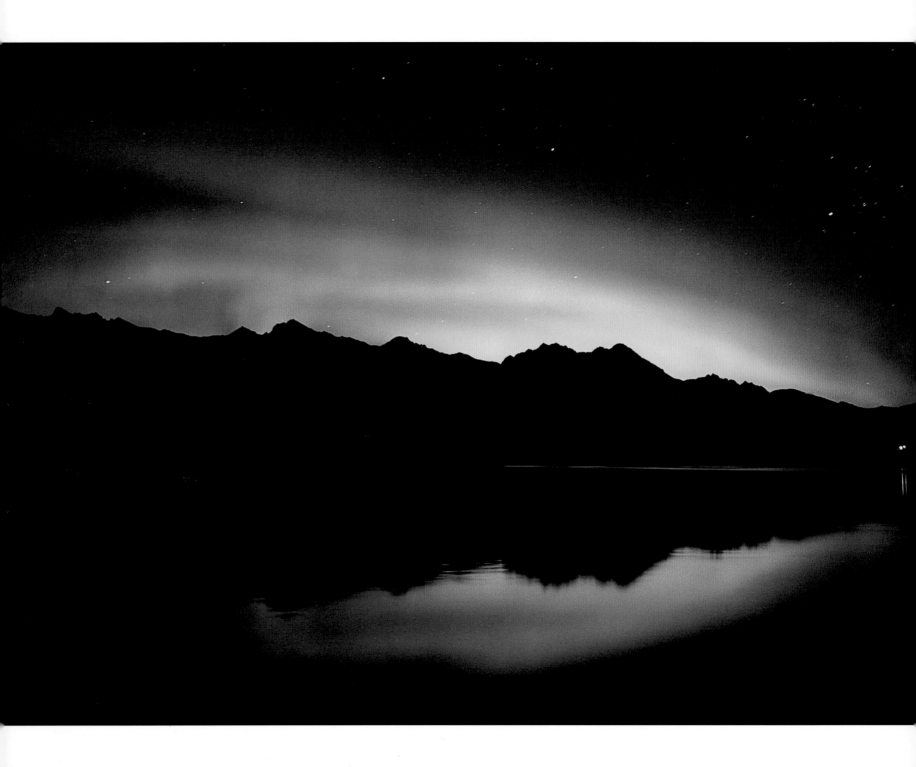

Moonless nights in the fall, before the lakes and rivers freeze, provide a good opportunity to create reflection images of the northern lights, such as these on the Knik River. LEFT: *The Chugach Mountains are silhouetted (October).* BELOW: *The cottonwood trees still have their leaves (September).*

FOLLOWING PAGE: *From a campsite several miles off the Parks Highway, Hale-Bopp Comet and the northern lights were observed on a calm, cold evening (March). After four hours of waiting, this band of lights curved down from the north and draped itself over Mounts Foraker, Hunter, and McKinley.*

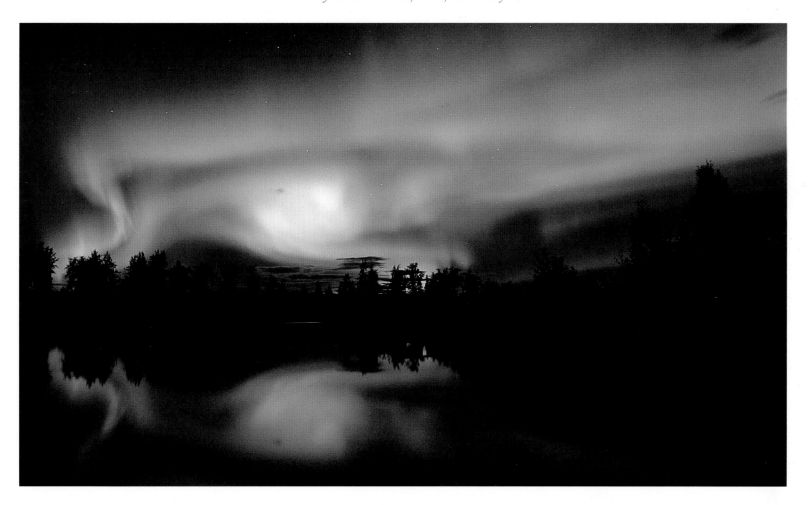

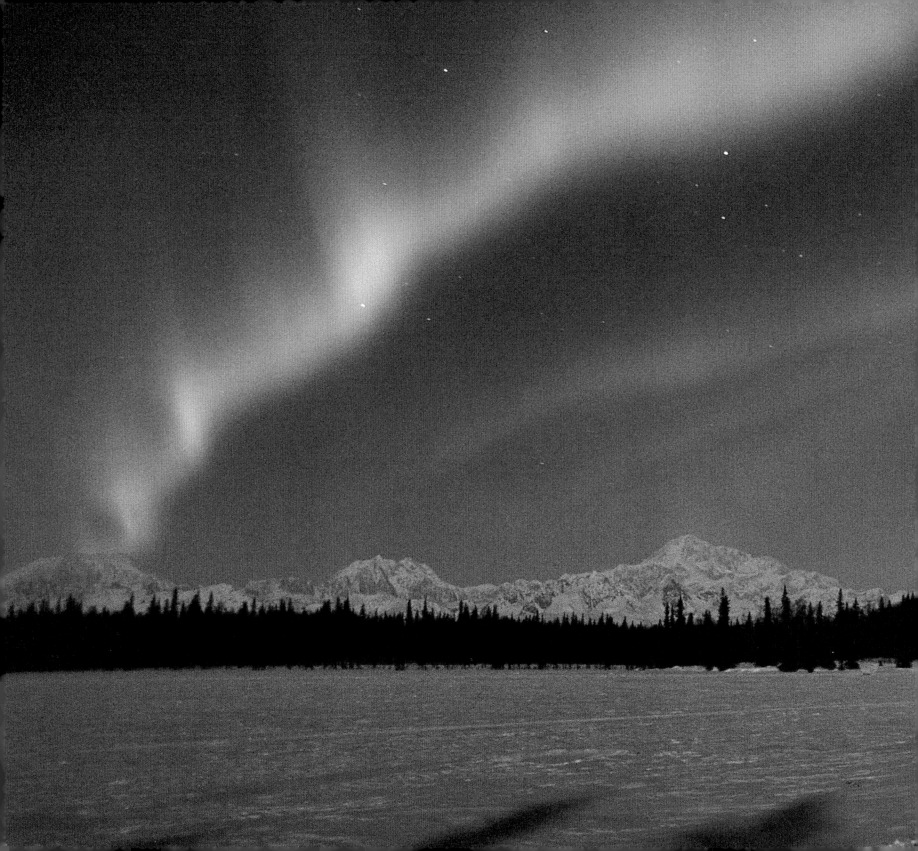

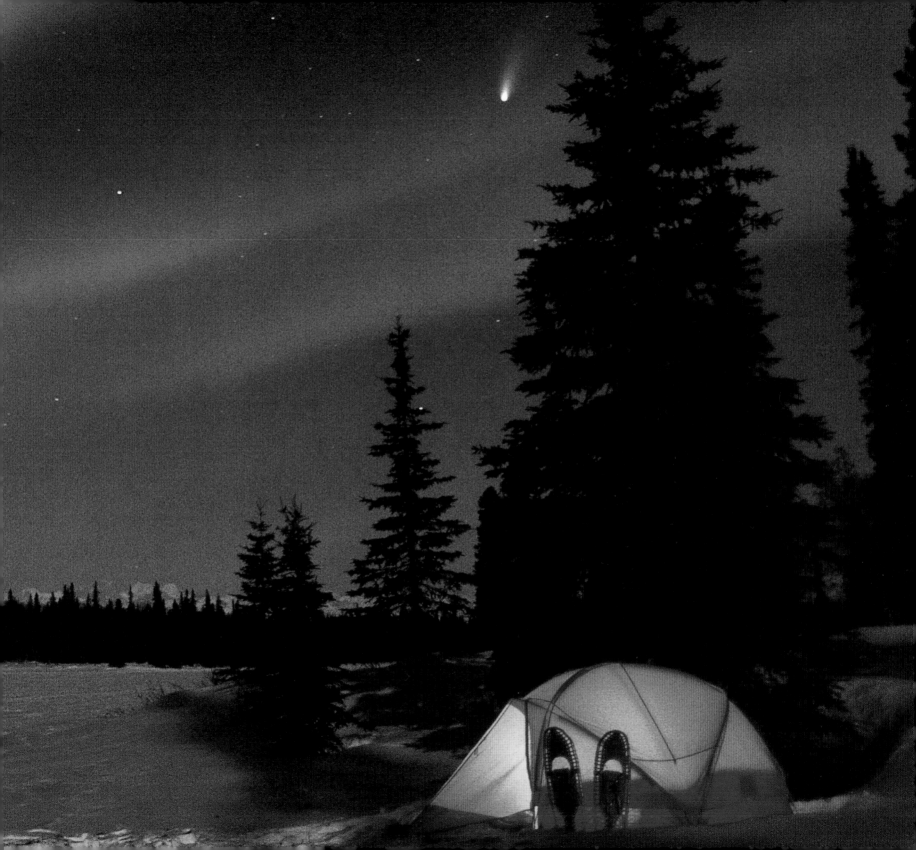

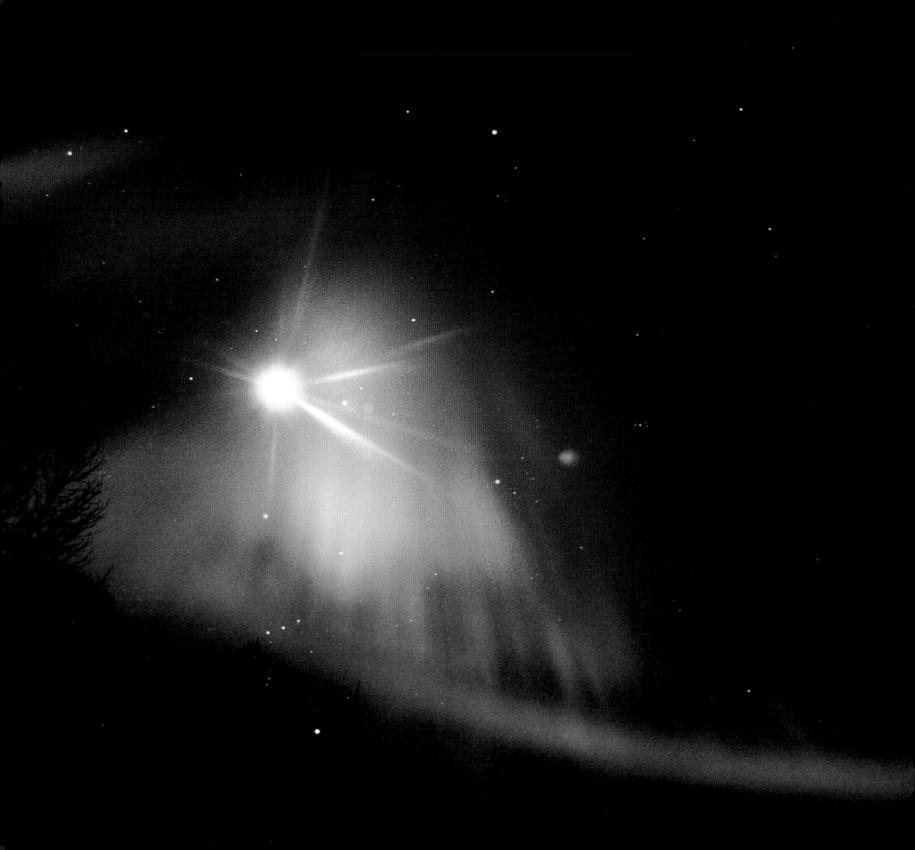

✦

WHAT THEY SAW

✦ ✦ ✦
✦

Throughout human history, the ancient hunters of the circumpolar

regions probably stopped whatever they were doing and marveled when the northern

lights appeared. Some undoubtedly gazed in wonder, while others were seized by fear or dread.

At a lower latitude, reactions to auroras were just as pronounced. The medieval

Christians of central Europe were invariably surprised by the northern lights, sometimes

even terrorized—partly because they saw them so rarely.

PREVIOUS PAGE: *Back-lit by the moon, these rays show many colors over Petersville, Alaska.*

LEFT: *A well-defined arc maintains a steady pattern as slowly moving auroral rays sweep across the sky above Bird Creek, Alaska (October).*

RIGHT: *An apparition of the Great Bear walks the ridgeline above the Ruth Glacier on Mount McKinley (November).*

Over Paris, auroras wouldn't have been visible more than a few nights a year. They wouldn't have appeared over Rome more than one night in a thousand. When they did appear, historians say, the auroras that extended as far south as central Europe were usually rich red—thoroughly disturbing the already active imaginations of the Middle Ages, or even the Renaissance.

"Bloody lances, heads separated from the trunk, armies in conflict were clearly distinguished [in the sky]," wrote nineteenth-century scholar Alfred Angot about perceptions of auroras in the 1500s. "At the sight of them people fainted . . . others went mad. Pilgrimages were organised to avert the wrath of Heaven manifested by these terrible signs."

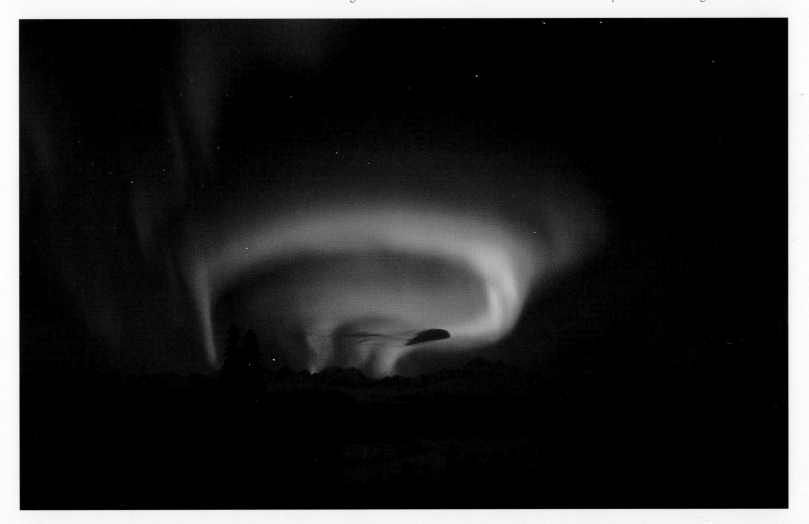

After the appearance of one such aurora in September 1583, thousands of terror-stricken penitents began walking across France toward the great cathedrals of Paris and Reims to confess their sins. King Henri III diverted his attention from the far more bloody Wars of Religion long enough to note in his journal, "[the pilgrims] said they were moved to this penitential journey because of signs seen in heaven and fires in the air."

Northern Europeans, meanwhile, were probably less skittish. They were wary and sometimes fearful of auroras, certainly, but more out of respect than surprise. They knew the lights were really the celestial manifestation of their dead relatives. The world of the aurora was simply the world of the spirits.

BELOW: *In this image, taken in the Talkeetna Mountains near Palmer (February), the 17-mm wide angle lens could barely capture the aurora with the Big Dipper above it.*

RIGHT: *Even veteran photographers of the northern lights experience odd new shapes, such as this one which appeared to touch down over the Kenai Peninsula on Halloween night, 2000.*

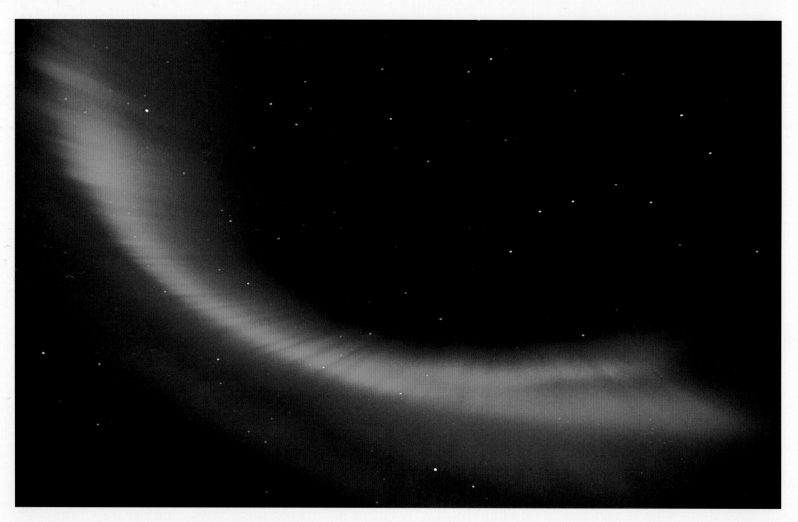

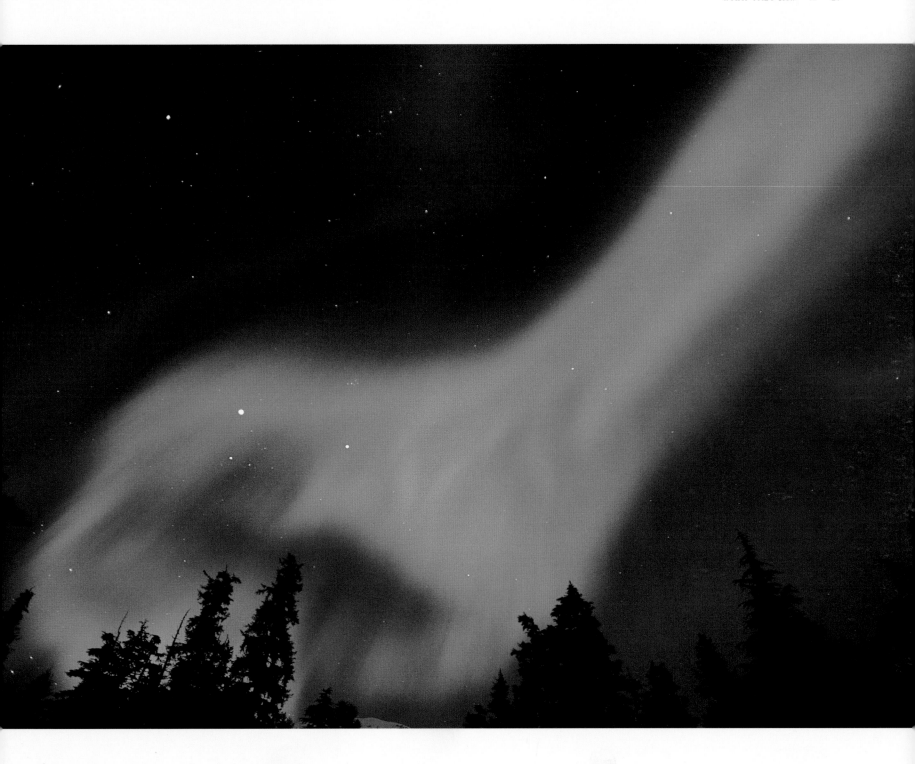

Ancient Scandinavians saw the northern lights as the recently departed souls of strong, beautiful women hovering in the air; or the ethereal forms of girls running around a fireplace; or images of women who had never married cooking fish over campfires and dancing. Early Norwegians thought the aurora was the sun reflecting off the shields of the Valkyries—the warrior-maidens who descended onto battlefields to choose among the slain those most worthy to reside in Valhalla.

More recently, Greenland Eskimos thought the aurora was the special province of all the children who had died in childbirth or by some other violent means. Sometimes these spirits were happy, and their dancing created the streamers of the northern lights; sometimes they were resentful, rushing down toward Earth to prevent the newly dead from reaching their realm.

By comparison, the Labrador Eskimos of eastern Canada believed the northern lights were the torches of friendly spirits trying to help anyone who had recently died to negotiate a narrow path over the chasm that separated the living world from the afterlife. "The whistling crackling noise which sometimes accompanies the aurora is the voices of these spirits trying to communicate with the people of the Earth," wrote Canadian anthropologist Ernest Hawkes in 1916 (though scientists say the northern lights are not capable of emitting sound). "They should always be answered in a whispering voice."

Few people knew the aurora as well as the wide-ranging Inuit—the Eskimo people—who populated the Arctic from Siberia to Alaska to Canada to Greenland. They lived closer to the magnetic North Pole than anyone else. Their home was the auroral zone. When they died, according to members of a tribe of Eastern Canadian Eskimos interviewed in the early twentieth century, the most fortunate among them spent their next life in the sky, in the Land of Day, where dead Inuit occasionally clashed in a great auroral soccer game.

In the 1920s, Danish explorer Knud Rasmussen heard stories about this afterlife while traveling 4,000 miles by dogsled from Greenland to Alaska, living among the Inuit and listening to their tales. "It is said that the Land of Day is the land of glad and happy souls," he wrote. "The people there live only for pleasure. They play ball most of the time, playing at football with the skull of a walrus, and laughing and singing as they play. It is this game of the souls playing at ball that we can see in the sky as the northern lights."

In another account, he added, "A whistling, rustling, crackling sound is made by the souls as they run across the frost-hardened snow of

In Denali National Park, an eerie skull figure forms above Mount McKinley.

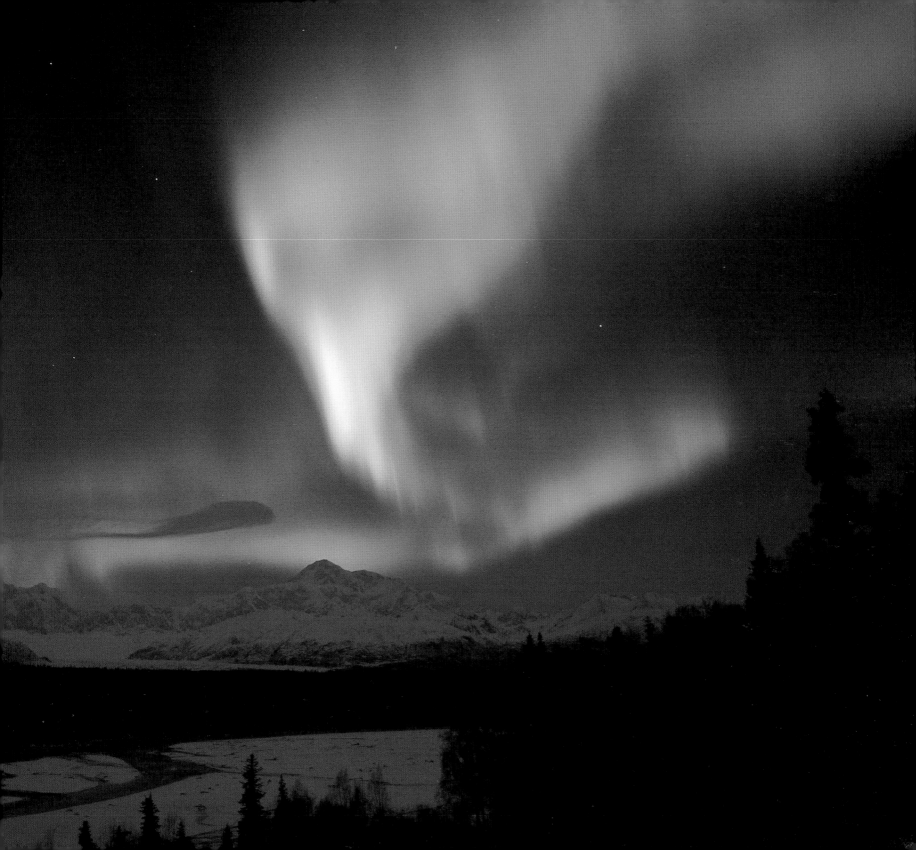

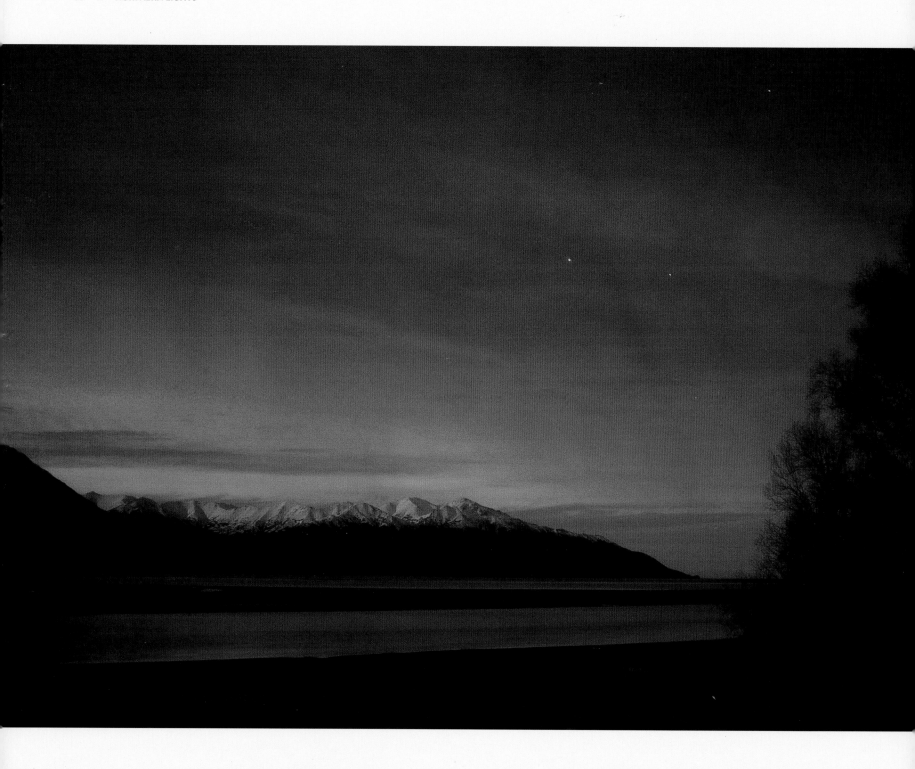

A blood red sky hangs above the old gold mining community of Hope, Alaska (October).

———————•———————

"THE TOUGHEST PART WAS
TRYING TO FIGURE OUT WHICH
WAY TO AIM YOUR CAMERA," HE SAID.
"YOU'D LOOK ONE DIRECTION AND IT WAS
SOLID RED. YOU'D LOOK ANOTHER
DIRECTION AND YOU HAD FIVE BANDS OF
JUST UNBELIEVABLE GREEN. YOU HAD
MCKINLEY SITTING IN FRONT OF YOU
THAT'S WELL-MOONLIT, BUT
YOU'D ALREADY SHOT A HUNDRED PIC-
TURES OF THAT—SO WHICH WAY
ARE YOU GOING TO TURN THE
CAMERA? . . . IT WAS PHENOMENAL."

———————•———————

the heavens. If one happens to be out alone at night when the aurora borealis is visible, and hears this whistling sound, one has only to whistle in return and the light will come nearer, out of curiosity."

Yupik Eskimos of western Alaska used to "whistle down" an aurora in just this way, according to research by Alaskan anthropologist Margaret Lantis. But Yupiks who lived on Nunivak Island in the Bering Sea said the celestial soccer game was actually played by walruses kicking around the skull of a human.

Sometimes the northern lights brought bad news. The Eyak Indians near Cordova thought they prophesied a violent death. The Tlingit Indians of Southeast Alaska saw them as a clear sign of an approaching battle. Among Inuits, only the Point Barrow people considered the aurora an evil entity, wrote Dorothy Ray, a mid-twentieth-century author of several books on the Eskimo and Athabaskan cultures. "In the past, they carried knives to keep it away from them."

Velma Wallis, the popular author of *Two Old Women*, has never carried a knife to protect her own life against the northern lights. But as she was growing up in an Athabaskan family of thirteen children in Fort Yukon—ground zero for the aurora borealis—she was instructed to respect auroras, and sometimes even fear them. "We were told that the northern lights was a spirit," she said recently. "All the elements of nature were spirits . . . and you could easily rouse the northern lights by whistling."

You weren't supposed to do that, Wallis said; the rule against whistling at the aurora was very clear. "There were stories of people who had whistled at the northern lights . . . and they were taken."

Sometimes a bright red aurora would be seen, and then a few days later someone would die, she said. "And the people would say, 'The northern lights did that.'"

It was hard for a little girl not to be frightened, growing up in a place where there were so many auroras that did such powerful things. "Lots of times we would hit the ground and we could hear the crackling of the northern lights. . . . In retrospect, I remember them being almost alive. It was a presence."

Velma and her friends became less afraid of the aurora as they grew older. One night, when they were looking at the lights for the thousandth time, Velma decided to try something. She whistled at the sky.

"And we could hear the ground *crackling.* The northern lights were growing more irate. . . . They got so close, it was like they were coming down to get us!"

Then Velma and her friends ran all the way home.

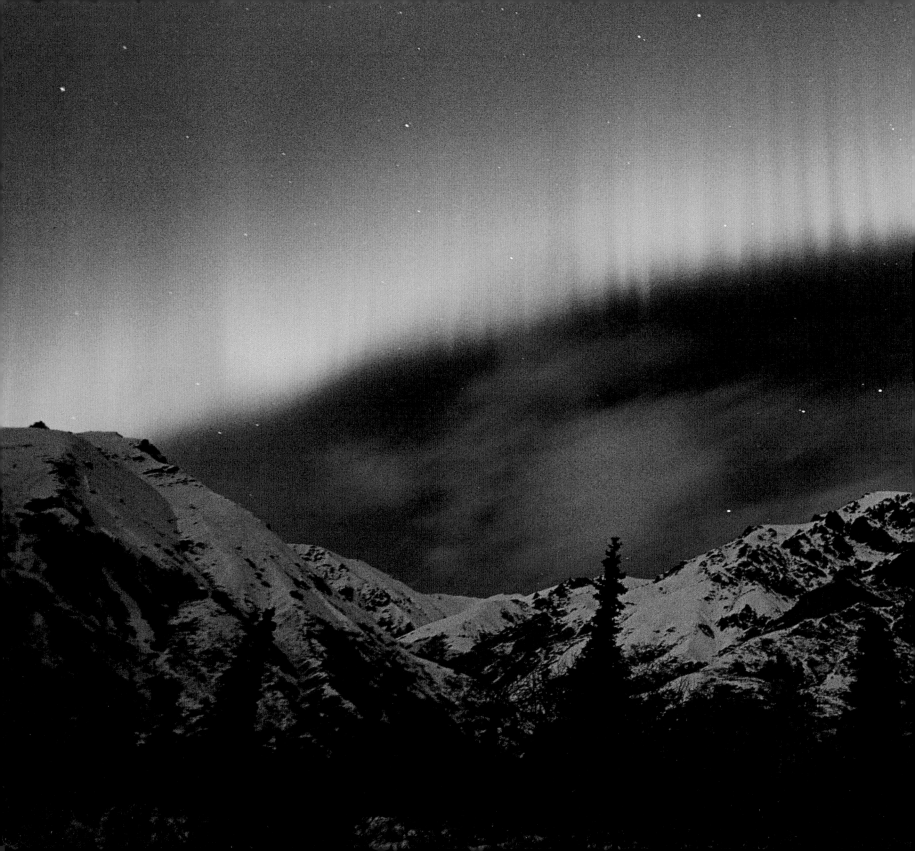

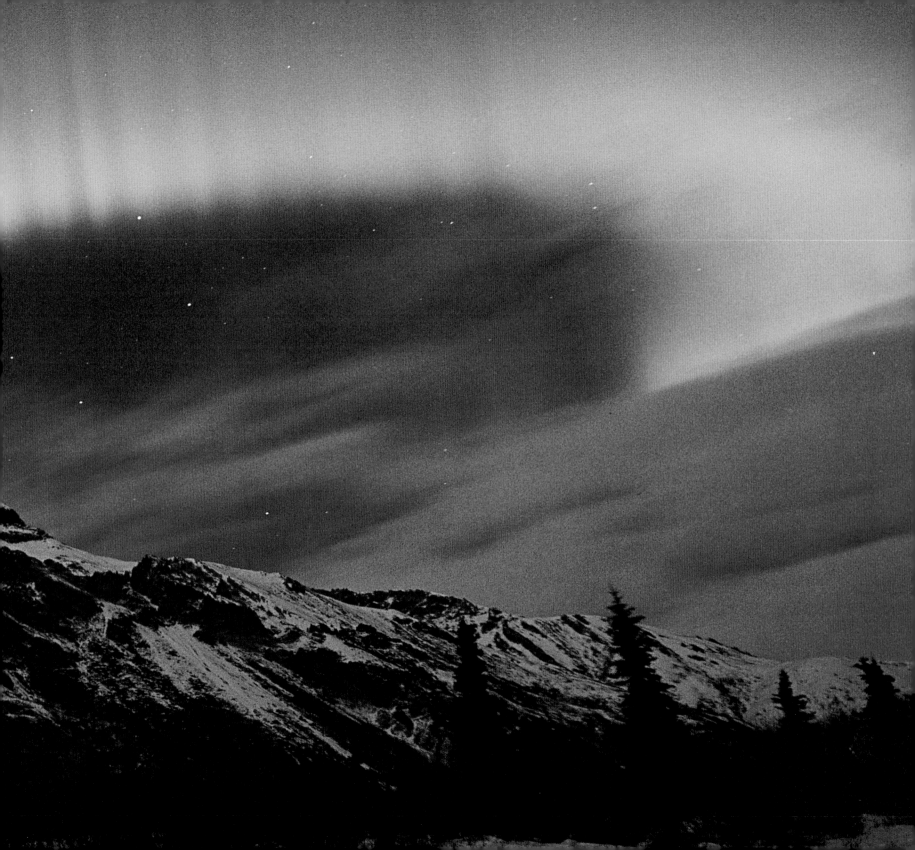

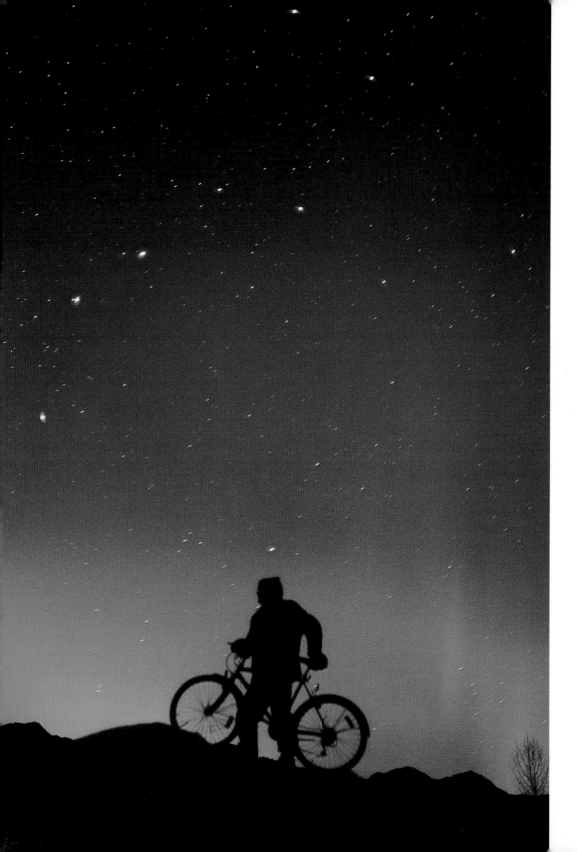

PREVIOUS PAGE: *In the fall, the Big Dipper appears closer to the horizon and upright, allowing for this perfect aurora shot at Sheep Mountain, Talkeetna Mountains (November).*

LEFT: *A mountain biker turns sky gazer as the northern lights start their amazing show in Southcentral Alaska (late October).*

RIGHT: *The extra set of lights in this photograph were on a semi-truck headed north on the Parks Highway (late March).*

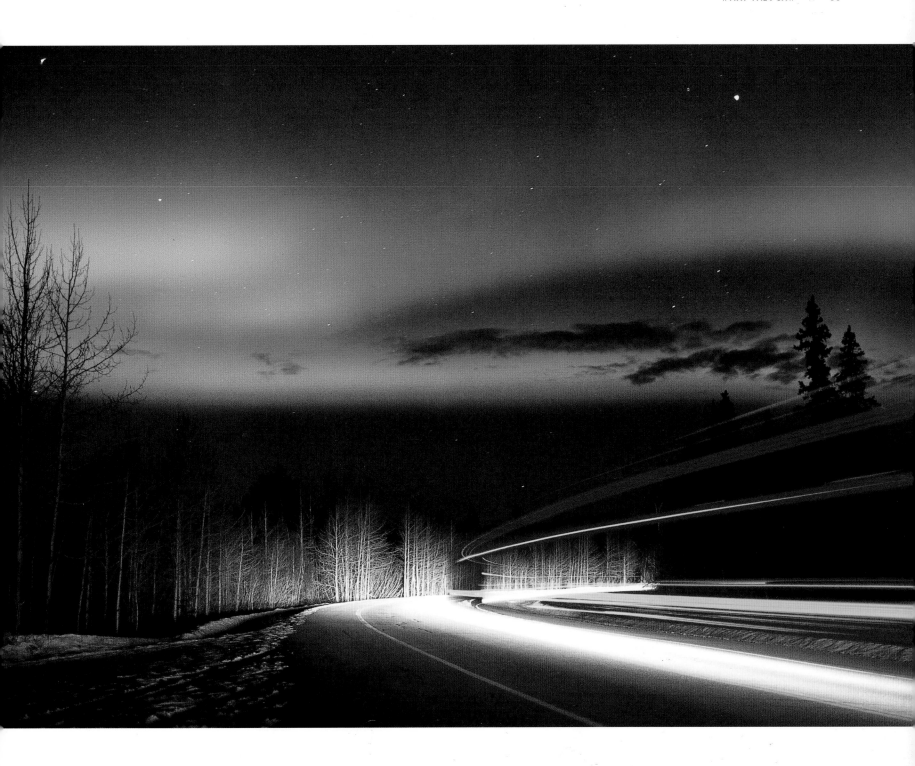

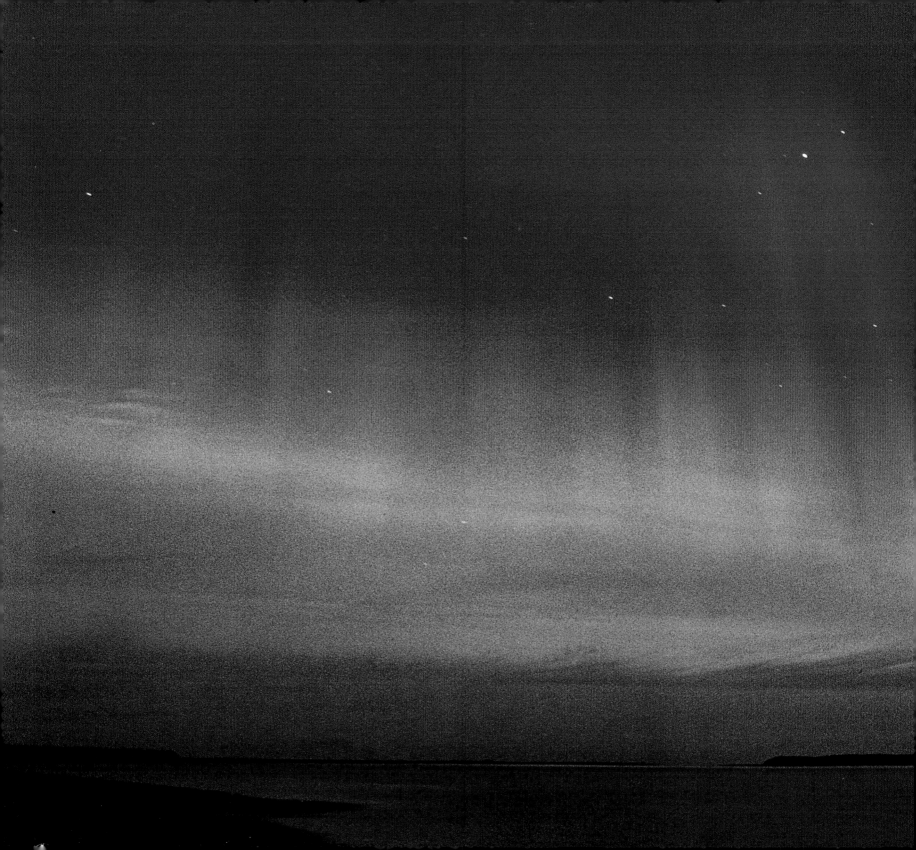

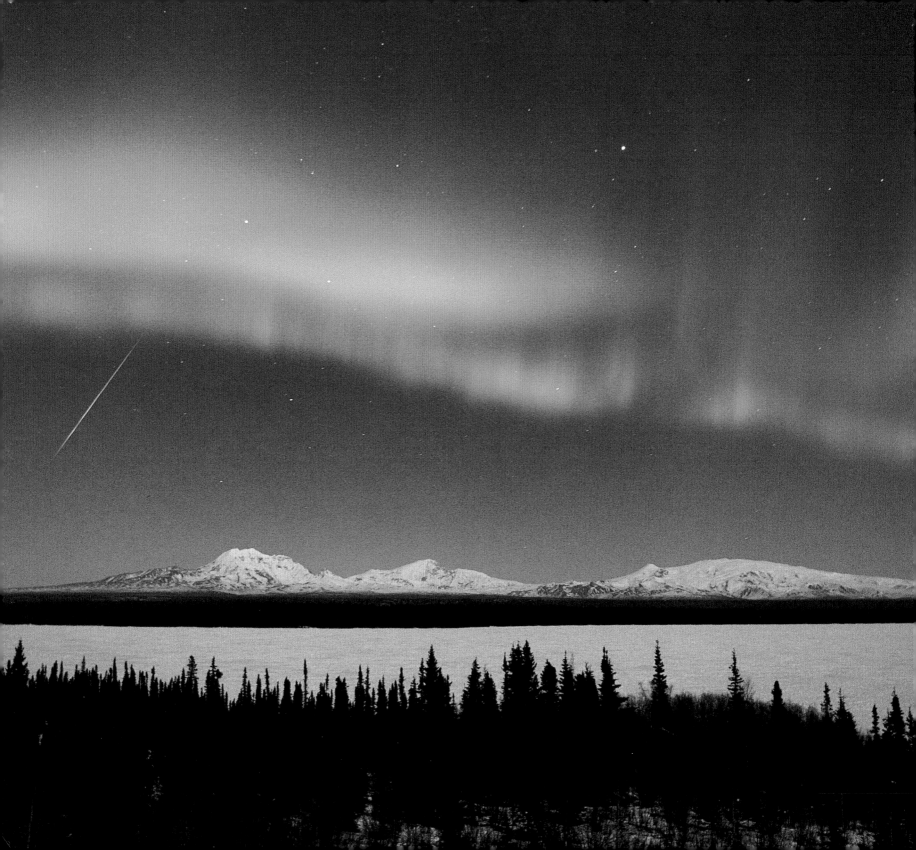

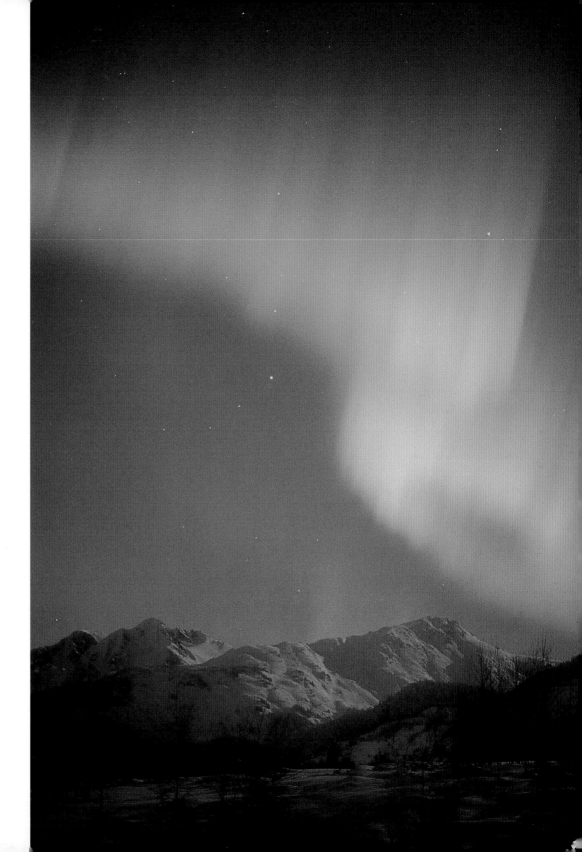

PREVIOUS PAGE: *After an unplanned, and uncontrolled, slide down the steep and frozen bluff of Point Woronzof in Anchorage, Calvin Hall ran out onto the beach just in time to capture this amazing red aurora above Cook Inlet (October 21–22, 1999).*

LEFT: *A bright meteor flashes across the sky while an aurora hangs over moonlit Mounts Sanford, Drum, and Wrangell in the Wrangell Mountains (late March). In the foreground is Willow Lake near the Richardson Highway south of Glennallen.*

RIGHT: *Northern lights dance over North Star Mountain in the Chugach Mountains (April).*

BELOW: *Translucent rays over Wasilla, Alaska (April).*

RIGHT: *A break between thick clouds allows Pioneer Peak near Palmer to complement a colorful display (early April).*

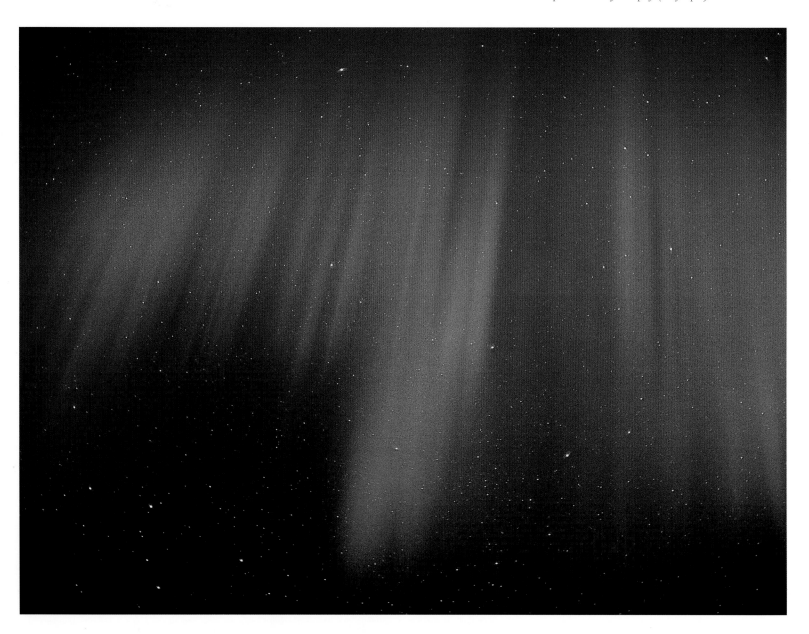

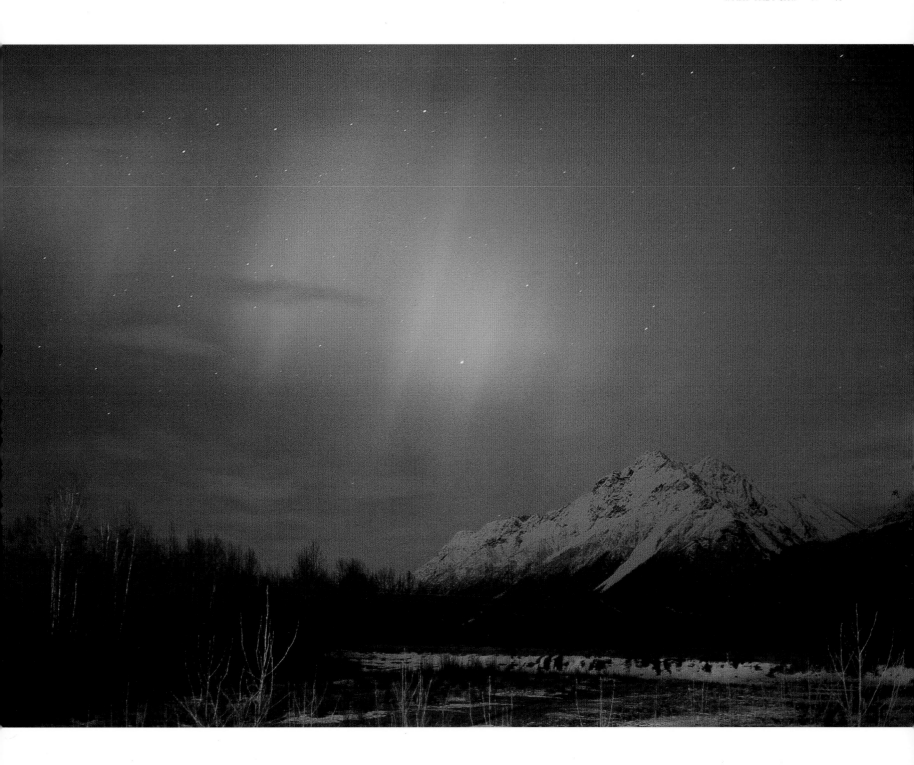

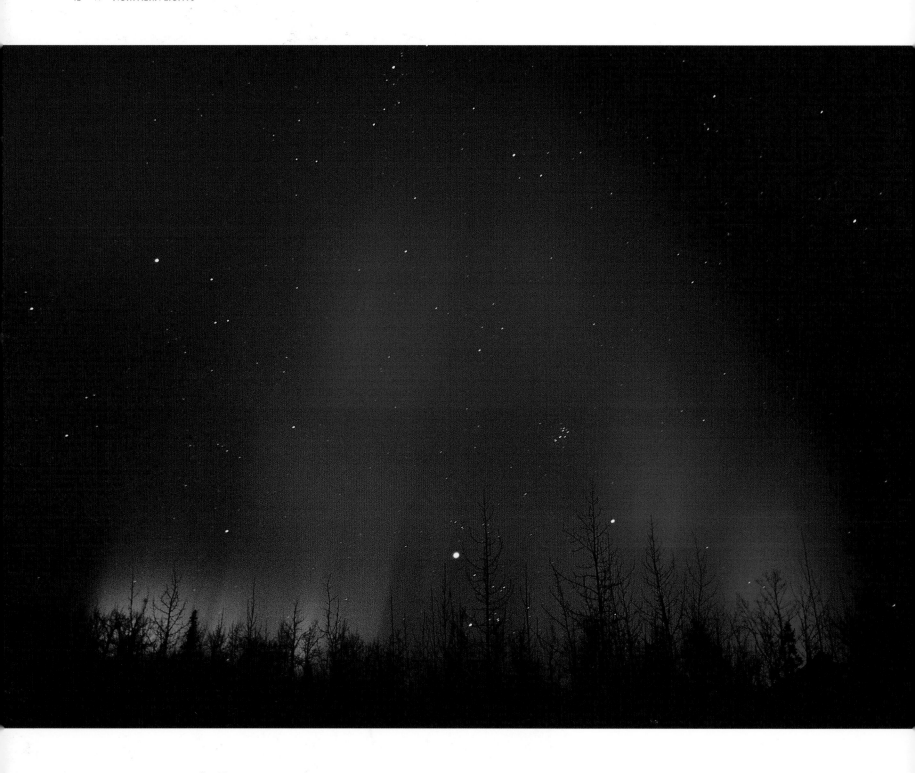

LEFT: *Just after dark, this intense red aurora appeared in the eastern sky near Sutton, Alaska (November 5, 2000).*

RIGHT: *While waiting for the aurora to appear, this 45-minute exposure was taken near Trapper Creek and reveals star trails as the earth moves.*

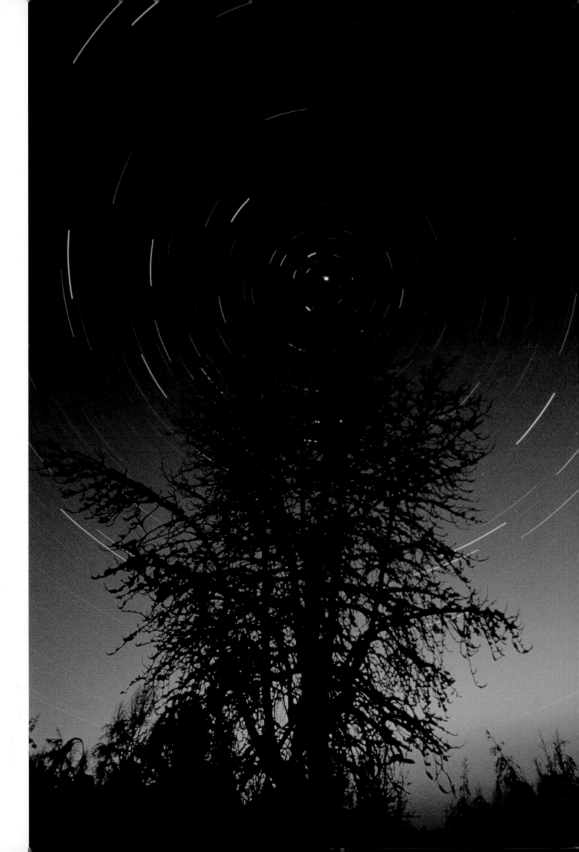

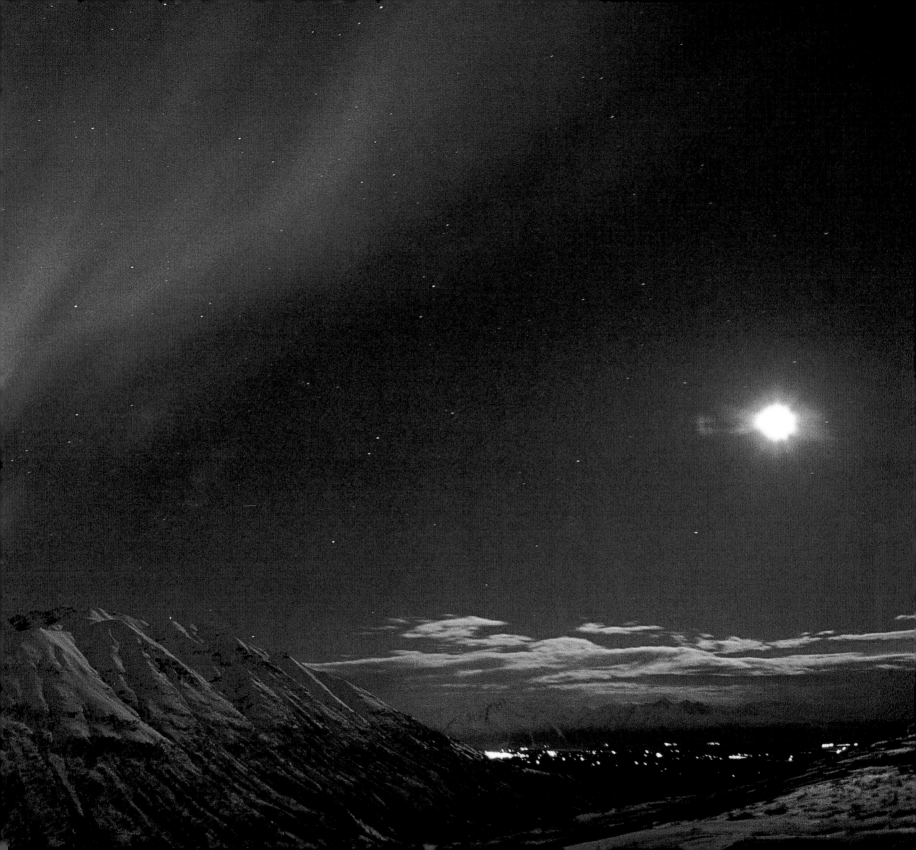

BEGINNING TO LEARN

History is full of people who thought they understood the aurora borealis.

The Makah Indians of the Pacific Northwest thought the lights were the reflection of fires that

people of the Far North lit to boil big pots of whale blubber. That assumption proved wrong,

but the Makahs could take heart in knowing that Aristotle, Descartes, and Galileo had been wrong about

the northern lights too. Just as the distinguished Encyclopaedia Britannica *was still wrong as*

recently as 1910, giving credence to reports that auroras sometimes touch the ground.

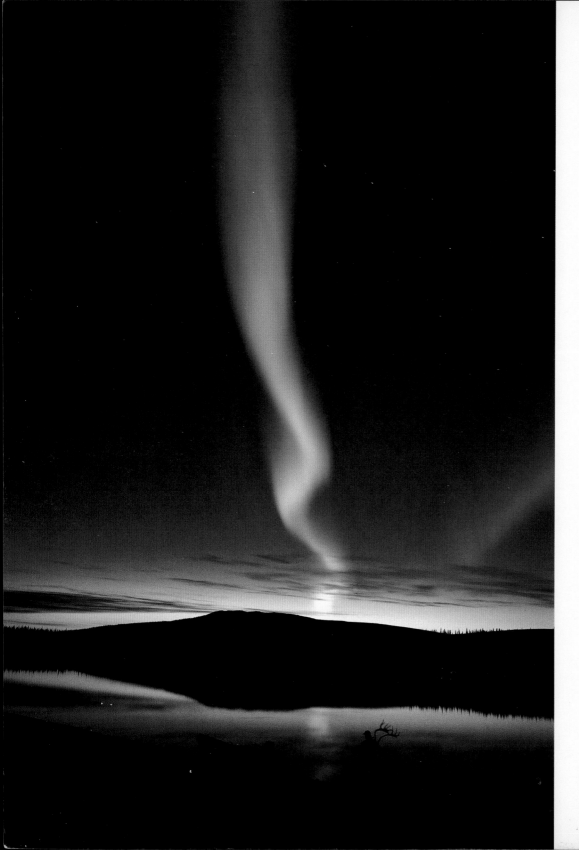

PREVIOUS PAGE: *This curtain of northern lights moved far enough into the southeast sky to photograph with the moon over Palmer (taken from Hatcher Pass, late February).*

LEFT: *A caribou hunter pauses to enjoy the auroral sunset reflecting on the Kobuk River, above the Arctic Circle (September).*

RIGHT: *The rugged Talkeetna Mountains near Palmer are lit by a half moon and a rich band of northern lights (November).*

Or parents are wrong today when they tell their children that an aurora is simply sunlight reflecting off the polar ice cap. It isn't.

What is it, then?

The answer has been a long time coming. Aristotle advanced one of the earliest theories some twenty-four centuries ago, insisting first of all that the source of the aurora couldn't possibly be found in the heavens, since the Sun and the stars never changed; it had to be found this side of the Moon. In his *Meteorologica*, Aristotle attributed auroras—as well as

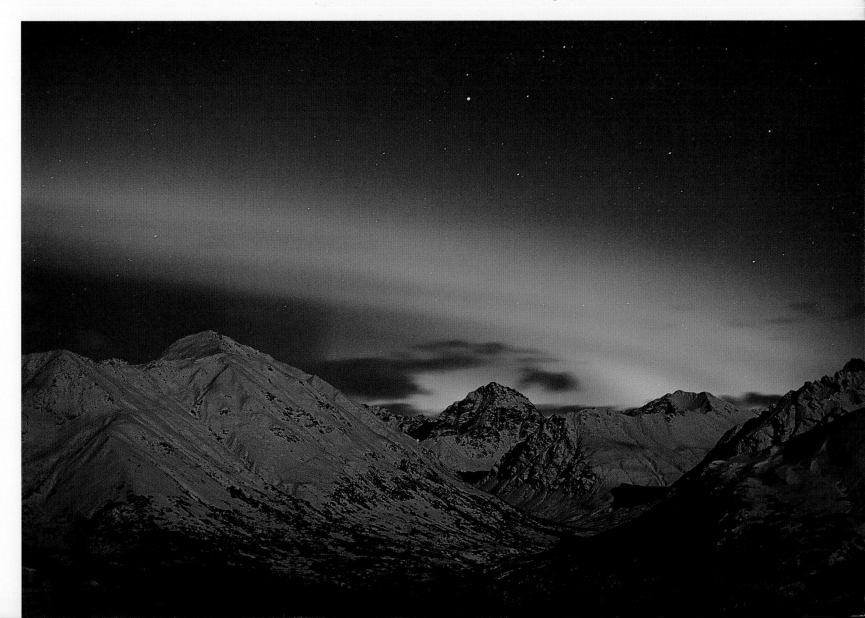

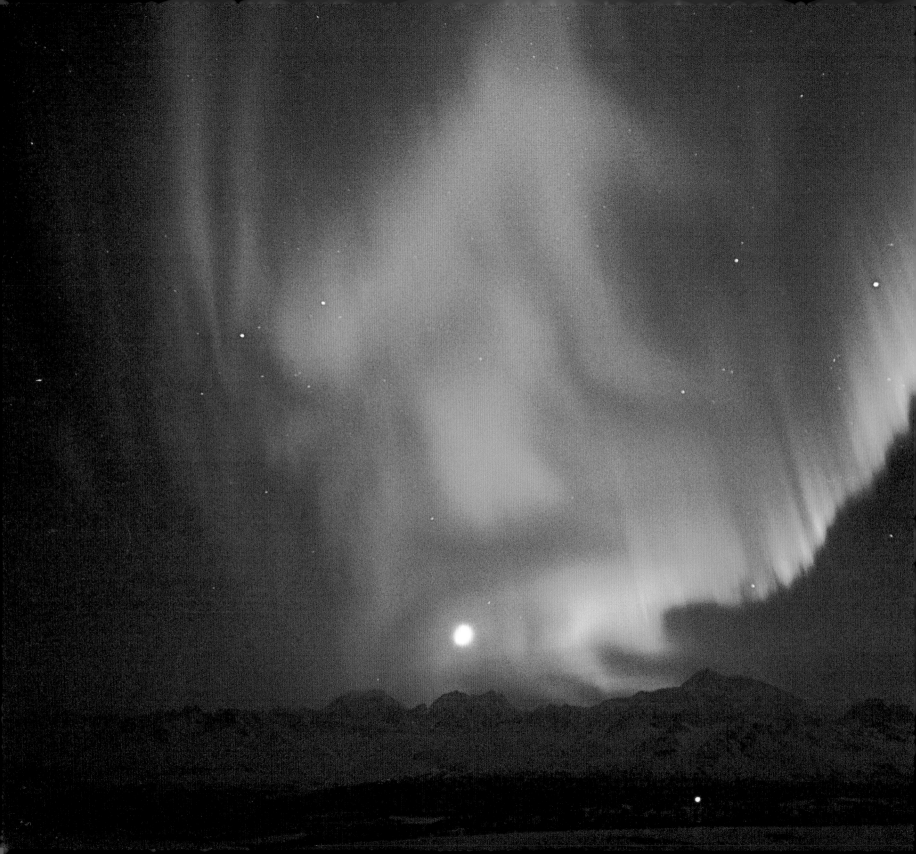

comets, meteors, and most other ephemeral lights in the sky—to earthly vapors that rise into the upper atmosphere and periodically catch on fire.

The earthly vapors weren't completely off the mark; at least atmospheric gas was part of the aurora puzzle. But as Candace Savage points out in her 1994 book *Aurora,* Aristotle's insistence that the heavens never change—a mistake Carl Sagan described as the "most influential error in the history of astronomy"—managed to confuse natural philosophers for the next nineteen centuries. It ruled out the role of the Sun and stars as agents of space weather and mistook geophysics for astrophysics. It turned everyone's attention toward Earth (the center of the universe) for all the answers. Not until 1572, when Danish astronomer Tycho Brahe noticed the creation of a brand-new star in the constellation Cassiopeia (the heavens *can* change), would academics again seek aurora explanations beyond the Moon.

But they still had a lot to learn. At the very least, the riddle of the aurora required a basic understanding of (1) solar physics, (2) the Earth's magnetic field, (3) electrical generators, and (4) neon signs—all of which were well beyond the ken of sixteenth-century encyclopedias. In fact, a Polish astronomer named Copernicus had only recently advanced his theory that the Sun was the center of the solar system instead of the Earth—and he wasn't enjoying much popular support.

(Even in the seventeenth century, an Italian astronomer who agreed with Copernicus would be arrested, tried, and forced to publicly declare under threat of life imprisonment, "I, Galileo . . . swear that I will never again say or assert that the Sun is the center of the universe and immovable, and that the Earth is not the center and moves." The Inquisition wasn't over, and the Age of Enlightenment hadn't quite begun—but science would stumble on.)

In the 1600s English physician William Gilbert demonstrated that the Earth is a gigantic magnet. In the 1700s astronomer Edmond Halley suggested that the northern lights might be influenced by that magnetism, which would help explain why auroras are most often observed in the polar regions, where the Earth's magnetic-field lines converge.

A half moon sets over the Alaska Range on an early April morning after a night of strong northerly winds. This image was taken from a ridge in the Talkeetna Mountains reached by snowmachine. A small "shelter" on the ridge had two feet of rock-hard snow on the floor and wind whistling through all the cracks. The next morning there were fresh wolf tracks just 100 yards away.

At that time, little was known about the southern lights—the aurora australis—that encircled the magnetic South Pole. The aboriginal people of Australia and New Zealand doubtlessly had seen them on their southern horizon, but few if

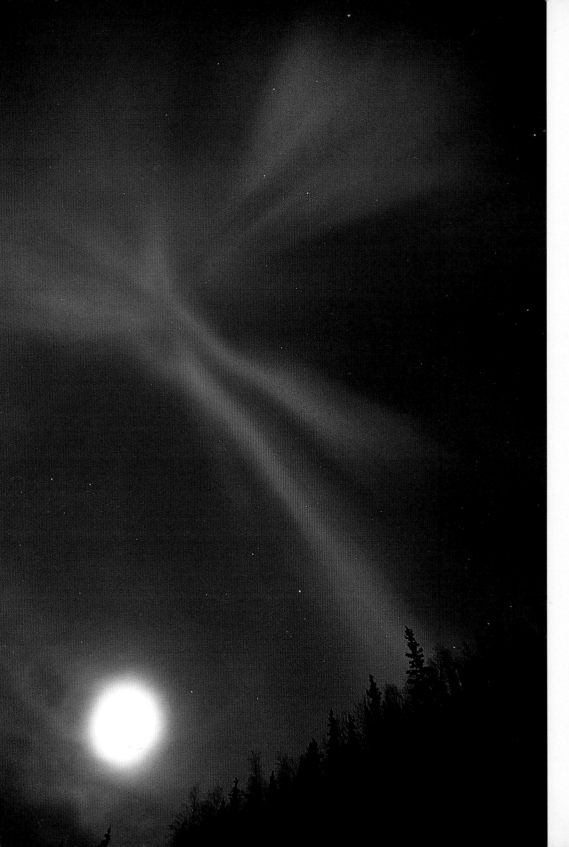

LEFT: *This highly colorful display of the aurora and moon was viewed near King Mountain on the Glenn Highway (March 30, 2001).*

RIGHT: *From this Knik River campsite with the Chugach Mountains in the background lit by a bright moon (October), piercing screams were heard moving gradually closer. It was the sound of a lynx. The animal came to within 75 yards of the camp before it stopped at the edge of the woods, screamed once more, and then wandered back into the night.*

any Europeans had (since the tip of Africa, the southern boundary of maritime commerce in the early 1700s, is no closer to the South Pole than San Francisco Bay is to the North Pole).

British explorer Captain James Cook first gazed upon the southern lights in 1773 during his initial historic voyage south of the Antarctic Circle. It was Cook who named them the "aurora australis," paraphrasing the recently adopted term for the northern lights, "aurora borealis." Seventeenth-century French scientist Pierre Gassendi had earlier coined the term *aurora*, Latin for "dawn," after Aurora, the ancient Roman goddess of dawn, likening the northern lights to a spectacular sunrise.

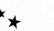

At the same time that Cook was admiring the southern lights, French scientist Jean Jacques d'Ortous de Mairan noticed a cause-and-effect relationship between solar activity—such as sunspots—and auroral activity. About the same time, American statesman, inventor, and amateur scientist Benjamin Franklin theorized that the northern lights were an electrical phenomenon.

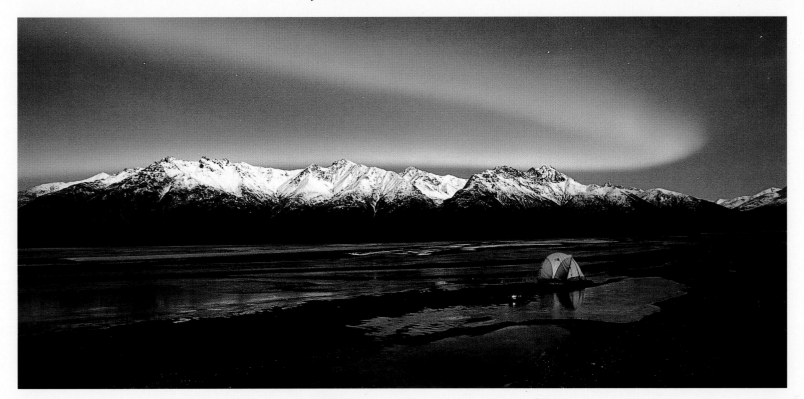

Throughout most of the nineteenth century, dozens of competing explanations for the northern and southern auroras jousted for prominence, while a unified theory remained elusive. All the parts were there—the Sun's role (though still vague), the Earth's magnetism (not fully explained), the role of electricity (also vague), and some knowledge about the properties of atmospheric gases—but no one yet had pulled them all together.

In the latter half of the nineteenth century, one more discovery would help close the circle. British physicist Sir William Cooke showed that a gas isolated in a vacuum tube glows if electrons are transmitted through the tube, and that different gases glow different colors (just as they do in "neon" advertising signs). Moreover, when Cooke moved a magnet near the tube, he saw that the stream of light inside bent toward the magnet.

At the beginning of the twentieth century, Norwegian physicist Kristian Birkeland finally made sense of it all: Rays of electrons explode off the Sun in all directions as solar wind. As the electrons stream past Earth, our planet's magnetic field steers a portion of them toward the poles. Moving through the Earth's thin upper atmosphere, the electrons collide with molecules and atoms of atmospheric gas and cause them to glow, just as gas had glowed in Cooke's lab experiments with electrical discharge tubes.

It wasn't simple, and it wasn't easily proven—satellites and spaceships having not been invented just yet—but Birkeland felt certain his explanation was correct. If it was, not many of his peers rushed to congratulate him. Everyone had theories of their own they weren't quite ready to relinquish, and no one had an aurora theory like the Norwegian's.

But subsequent discoveries in the early twentieth century would support Birkeland's hypothesis. In 1925 scientists at the Carnegie Institute determined that the ionosphere—a near-vacuumlike region of the Earth's upper atmosphere, where energetic electrons can flow relatively unimpeded—begins between forty and fifty miles above Earth and extends hundreds of miles higher.

That seemed to agree with the altitude of the northern lights, which had recently been measured by Norwegian physicist Carl Stormer. Using triangulation and thousands of photographs, Stormer had concluded that the bottom edge of nearly all auroras was sixty-two to sixty-five miles above sea level. The peaks of the auroras soared to between 200 and 600 miles above sea level. His conclusions placed the northern lights in the same realm as the ionosphere.

Stormer's measurements clearly compromised stories of auroras touching the ground, since the lowest aurora still fell fifty miles or so short of the highest landform. But reports of the northern lights appearing between two houses or touching a mountain continued to appear in newspapers for years to come. The reason is obvious, scientists say: The aurora borealis may well be the world's greatest optical illusion.

A swirl of northern lights silhouettes a small cabin in the Talkeetna Mountains (early April). The flag on the roof shows the strength of the wind; the blue color was created by the twilight of sunset.

THEN THE LIGHTS BEGIN TO COALESCE INTO A GENTLE CURTAIN-LIKE ARC, USUALLY PALE GREEN, THAT STRETCHES FROM THE EASTERN TO THE WESTERN HORIZON.

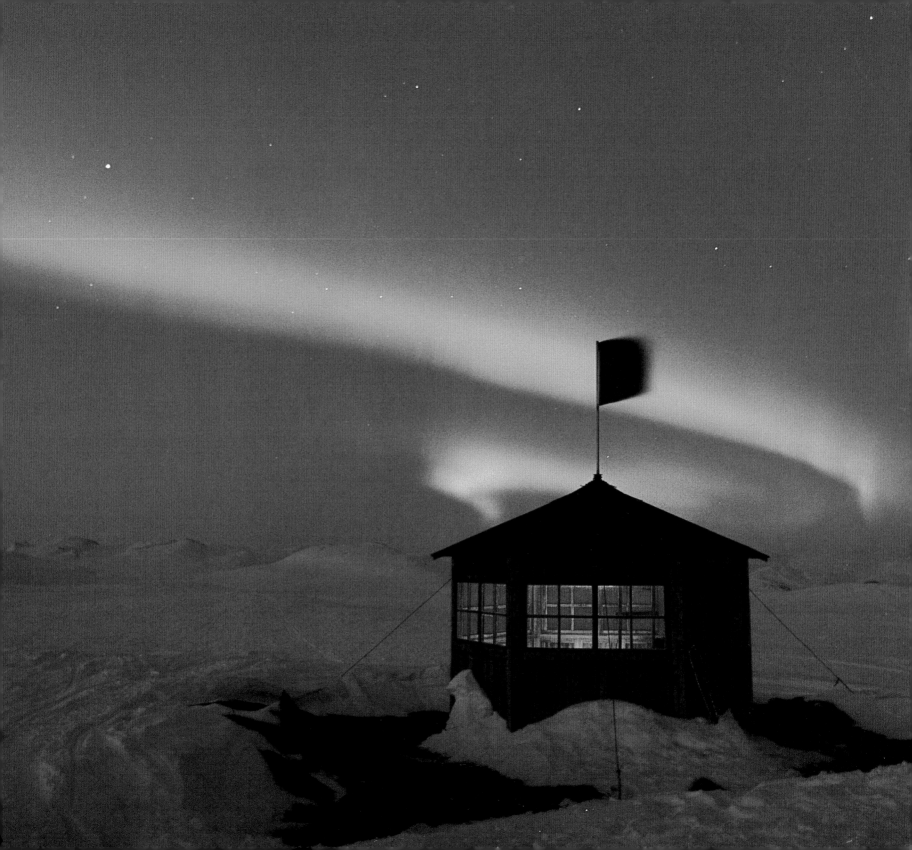

LEFT: *These spectacular auroras danced all over the sky above the Knik River Valley (September); with no wind, no snow, and temperatures above freezing, it was about as easy as it gets to enjoy the northern lights!*

RIGHT: *This photograph was taken on the edge of the Knik River just as ice was starting to form on the water (October).*

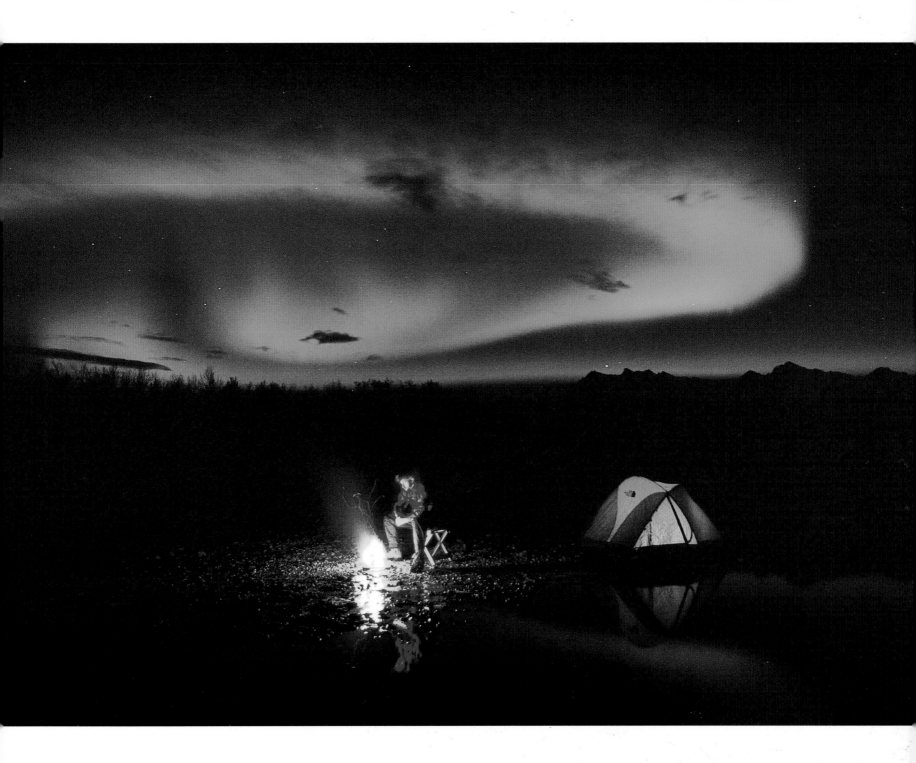

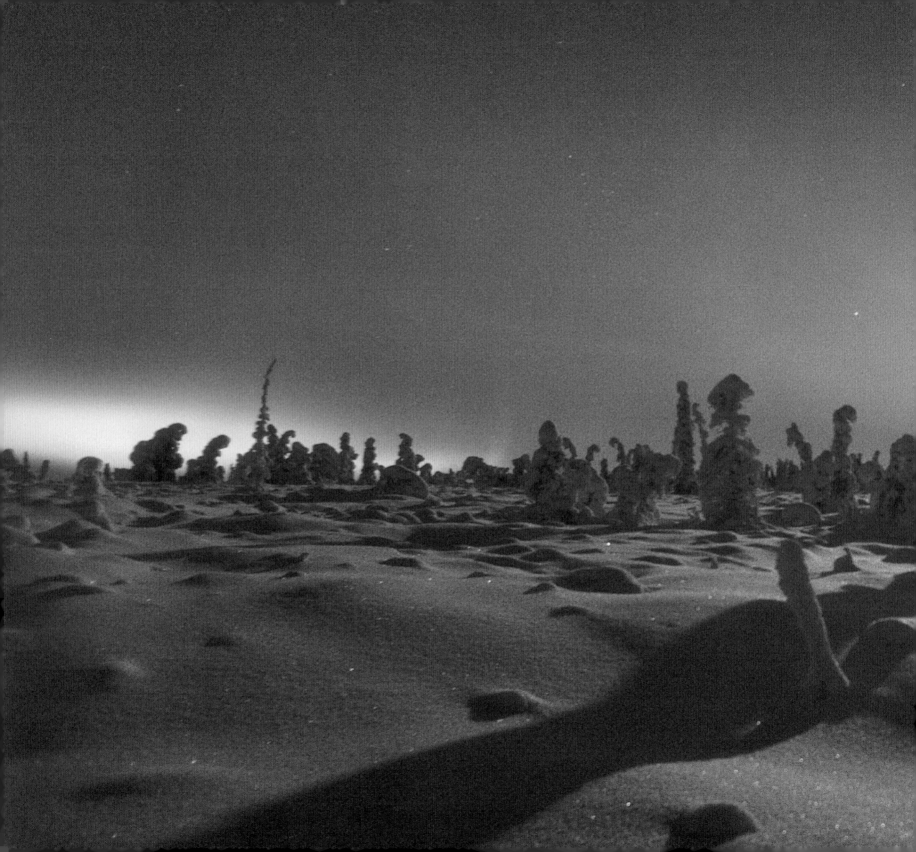

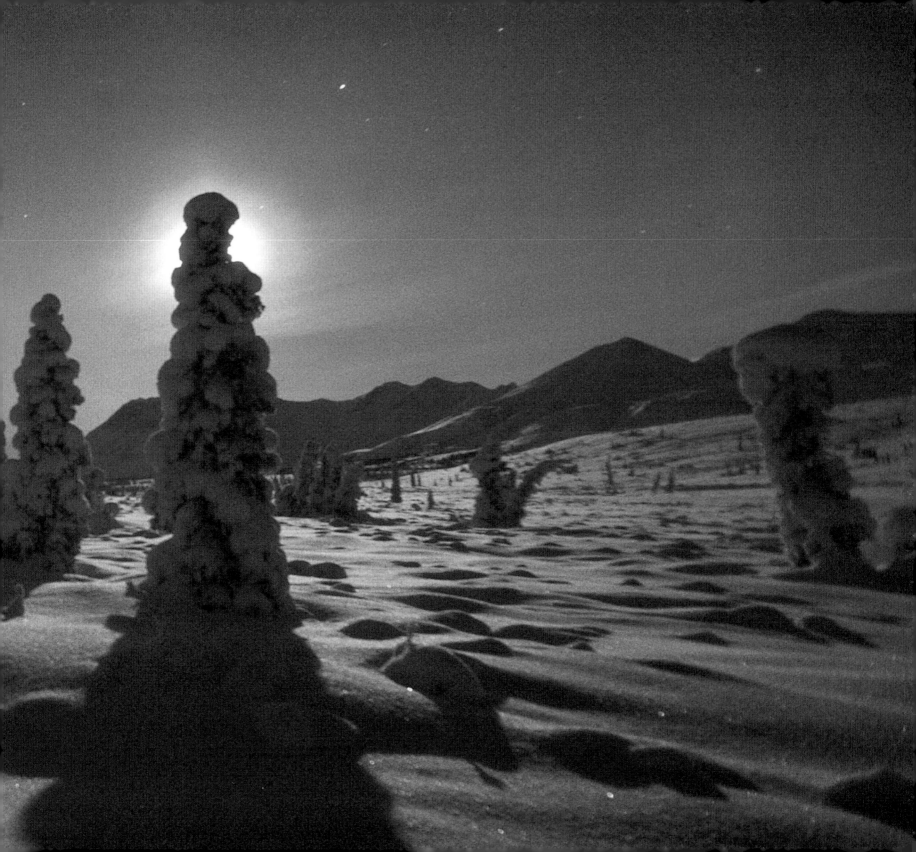

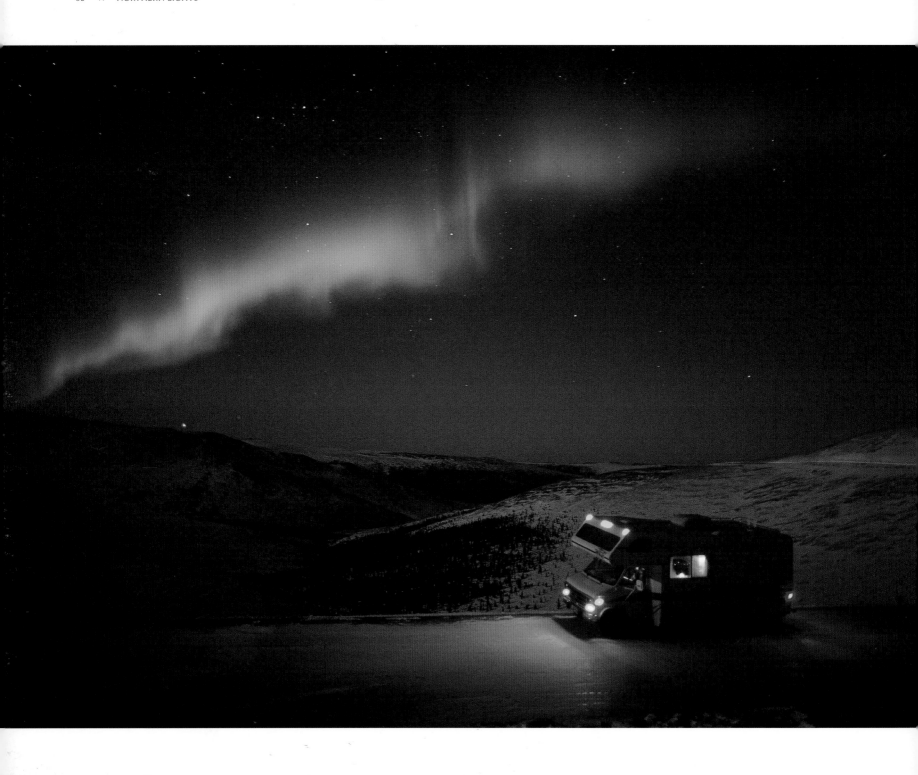

PREVIOUS PAGE: *A band of northern lights peeks over a winter wonderland near Eureka on a cold Alaska night—a camera-creaking -35 °F (early January).*

LEFT: *Night travelers often encounter the northern lights when driving the high latitudes of central Alaska, such as Twelve Mile Summit north of Fairbanks (late March).*

RIGHT: *Fire and Ice: Familiar Portage Lake offers a beautiful new reflection with its sculpted icebergs lit by aurora.*

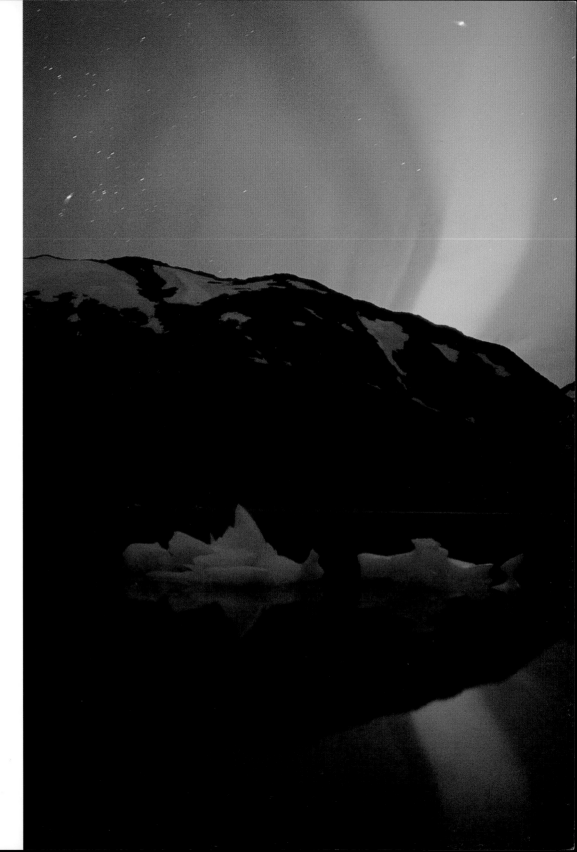

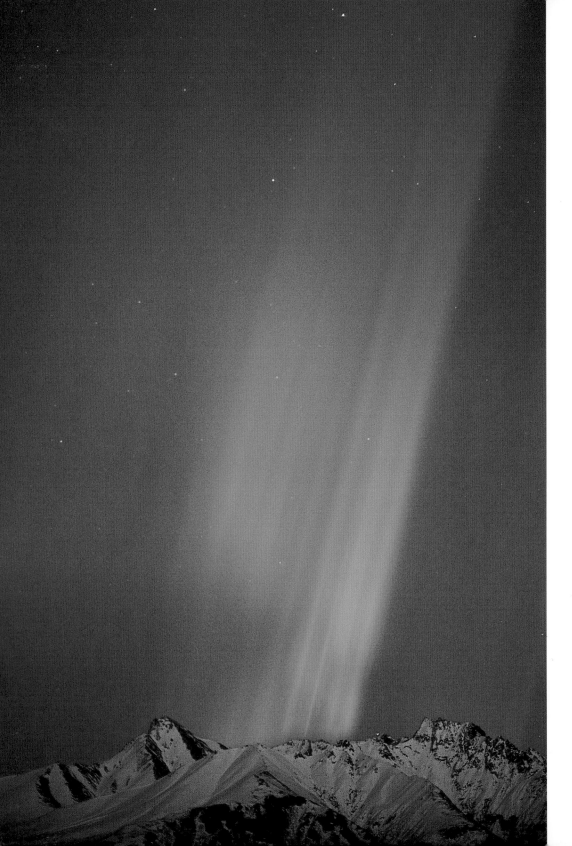

LEFT: *Matanuska Peak and Lazy Mountain host this early morning light show (late April). The color shift in the tall rays is an effect known as "resonance scattering," when sunlight mixes with the aurora.*

RIGHT: *Pink light emanates from the sky above Talkeetna, Alaska (early December).*

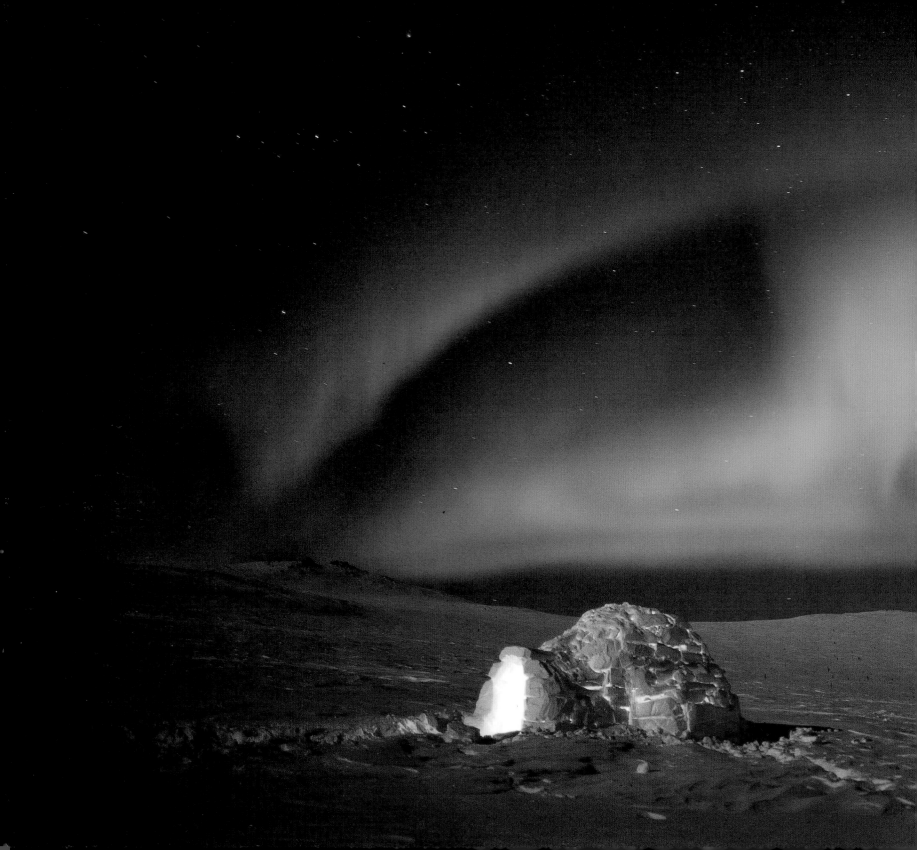

A hastily made igloo provides shelter from a brutally cold wind-chill on a winter's night north of Fairbanks, Alaska.

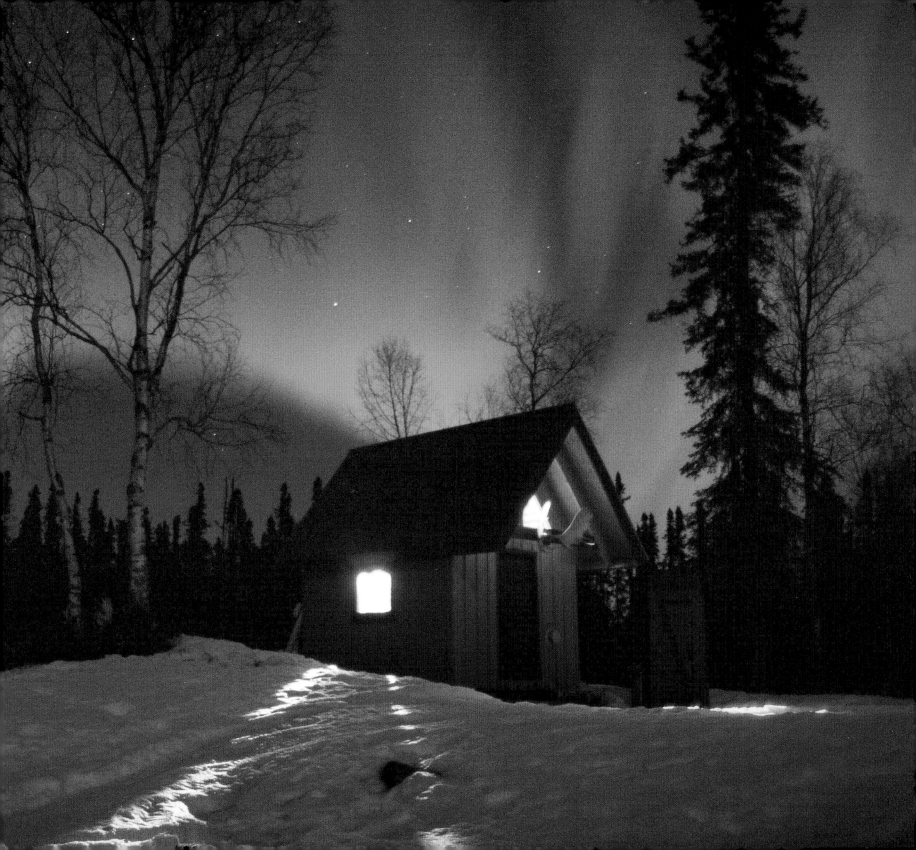

CURTAIN IN THE WIND

Auroras often follow patterns, or "substorms," that are

surprisingly predictable, but visually deceiving nonetheless. Scientists only discovered

the progression of these substorms a few decades ago.

In the Northern Hemisphere, an aurora usually first appears on the northern

horizon late in the evening, initially as a diffuse band of hazy clouds with little color. Then the

lights begin to coalesce into a gentle curtainlike arc, usually pale green,

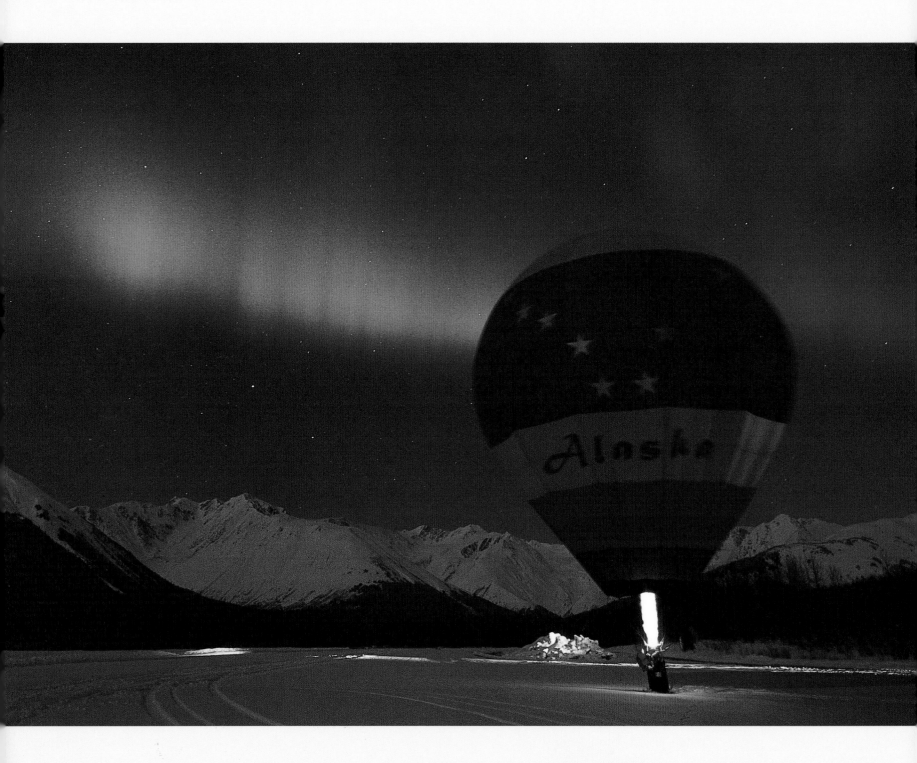

that stretches from the eastern to the western horizon. The apparent downward curve of the arc toward land or sea is deceptive; because the entire curtain may extend a thousand miles in length, it is simply curving around the globe—its entire lower edge maintaining the same altitude of sixty to sixty-five miles above sea level. The apparent height of the

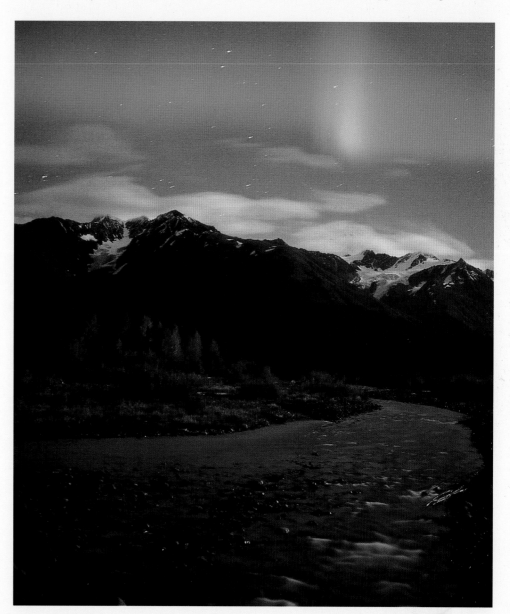

PREVIOUS PAGE: *This small cabin is off the Petersville Road at North Country B&B on Scotty Lake. The northern lights that night were very steady and visible from dusk until dawn (early April).*

LEFT: *A hot air balloon inflates as the northern lights dance along the mountains of the Girdwood bowl.*

RIGHT: *Glacier Creek and autumn foliage lie below as a slow rolling arc flares atop the Eagle Glacier.*

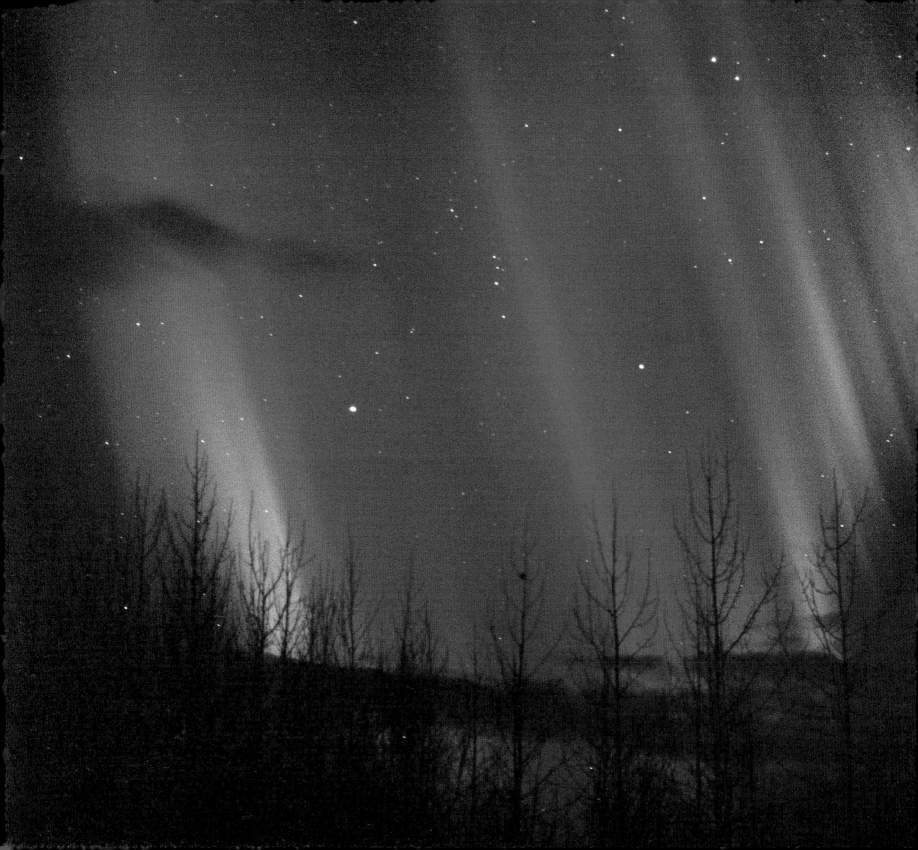

curtain is deceptive too. It's actually much taller than it seems, soaring anywhere from a hundred to five hundred miles from its bright, sharply defined base to its hazy, uneven crown. (The tallest northern lights extend high enough to be viewed more than a thousand miles south of their actual latitudes.)

As the aurora becomes more active, it develops fine vertical folds and the color grows stronger. Then the rays begin to ripple sideways, like a curtain brushed by a single gust of wind. The display might shift farther south, closer to where we are—changing our perspective from two-dimensional to three-dimensional as we glimpse beneath the aurora. We might see parallel rows of three or four or five curtains, as though we were looking up a ruffle of petticoats. An especially active aurora might develop a pink or crimson glow along its bottom edge. Then the curtain might roll back on itself, twisting and shifting in constant motion. It might begin pulsing, or exploding vertically. The stronger the aurora, the faster the movement.

While the overall length of any single auroral curtain can span from the Pacific Ocean to North Dakota, its width—just a mile wide—is almost wafer-thin by comparison. Still, as it passes overhead to the south of a viewer, the curtain appears to break apart (since it's more akin to a string curtain than a whole-cloth curtain), and aurora watchers may briefly observe a "corona," which looks like a sunburst, with rays extending in all directions from a center point straight overhead. Actually, it's just another optical illusion. In reality, the rays are all parallel and approximately vertical.

Having spent its wave of geomagnetic energy, the aurora begins to fade, scattering into patchy, nondescript haze and eventually disappearing—unless another wave of auroral energy happens along and the pattern begins anew, which it sometimes does, two or three times a night.

The colors of the aurora are determined primarily by the kinds of atoms or molecules the electrons strike. The most common color, greenish-white, appears when electrons bombard atoms of oxygen at relatively low elevations. The crimson red tinge that sometimes accompanies the bottom edge of green auroras appears when electrons plunge a little lower in the atmosphere and strike nitrogen and oxygen molecules. Electrons colliding with nitrogen molecules at the highest elevations when twilight shines on the upper atmosphere near dusk or dawn—especially

Daryl Pederson has become very adept at forecasting the northern lights using space weather web sites. Excited by the potential viewing on April 6, 2000, he and Calvin Hall tried to find holes in the clouds. Hall ended up north of Willow where he captured this red display as the clouds cleared and, over a three-hour period, saw every color in the rainbow.

in the fall or spring—may produce dramatic blue and violet auroras. The strongest elec-
tron storms of all can turn the entire sky blood red when atomic oxygen is bombarded
throughout the ionosphere.

The best time of day to view auroras is between nine in the evening and three in the
morning. The best time of year is between September and April. It doesn't need to be cold,
but it does need to be clear and relatively dark. Since geomagnetic storms usually last
longer than a day, one good night is often followed by another. And because solar flare
activity, which releases the electrons that power the aurora, may continue in the same
region of the Sun for many months—and the Sun rotates on its axis once every twenty-
seven days—one good night in February is likely to be followed by another good night
twenty-seven days later.

Finally, there are aurora-rich years and aurora-lean years. They trend up or down
depending on exactly where we are in the eleven-year-long sunspot cycle—a period that
tracks the Sun's eleven-year-long magnetic field cycle—which determines the frequency of
sunspots, the knots of magnetic turmoil on the Sun's surface that give birth to solar flares.
The most recent "solar maximum" of sunspots occurred in February 2001. Sunspot fre-
quency should remain high through 2004. Then the five-year-long "trough" of the cycle
will see a period of fewer sunspots, until their frequency begins to rise above the average
again in 2009.

This aurora over Turnagain Pass seems to have a red heart,
appropriate as it was active on Valentine's Day.

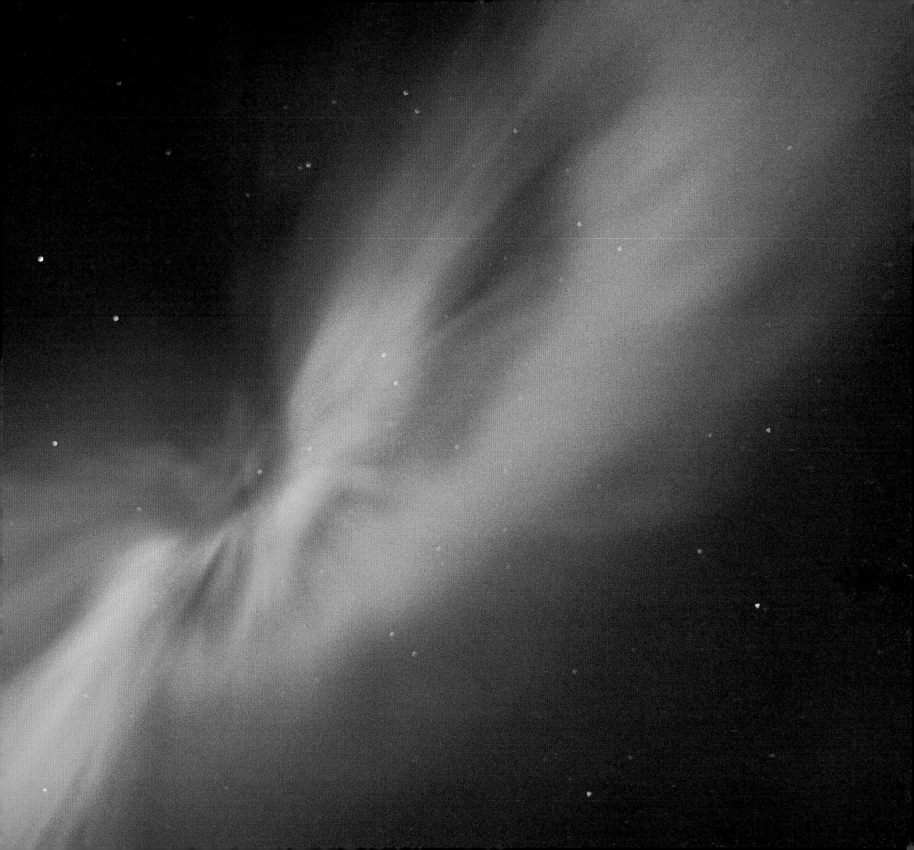

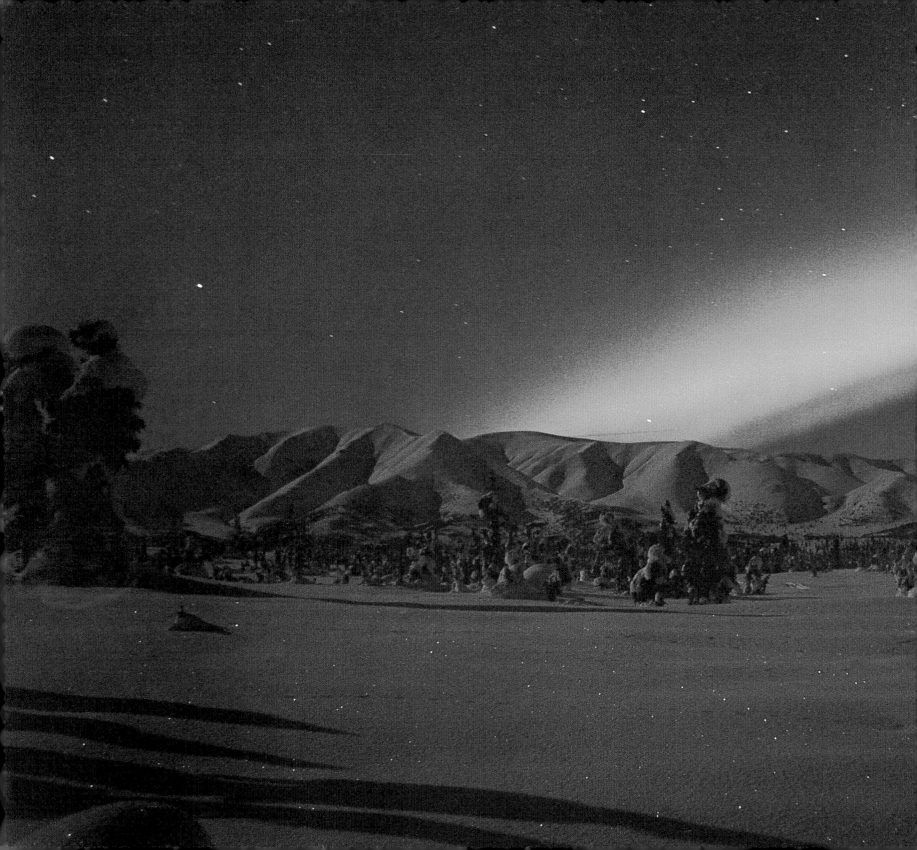

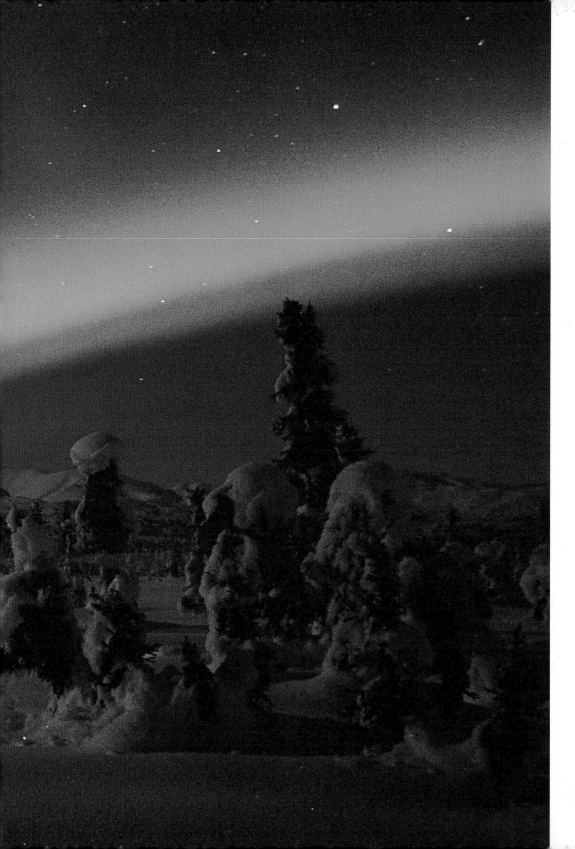

The sparkles on the ground in front of Syncline Mountain in the Talkeetnas are frost crystals that have grown on the snow and are lit by the moon (mid-February). This area near Gunsight Mountain on the Glenn Highway is protected by a rain shadow created by the Chugach Mountains to the south, so it has clearer weather, colder temperatures, and less precipitation then the surrounding area, creating the frosty conditions.

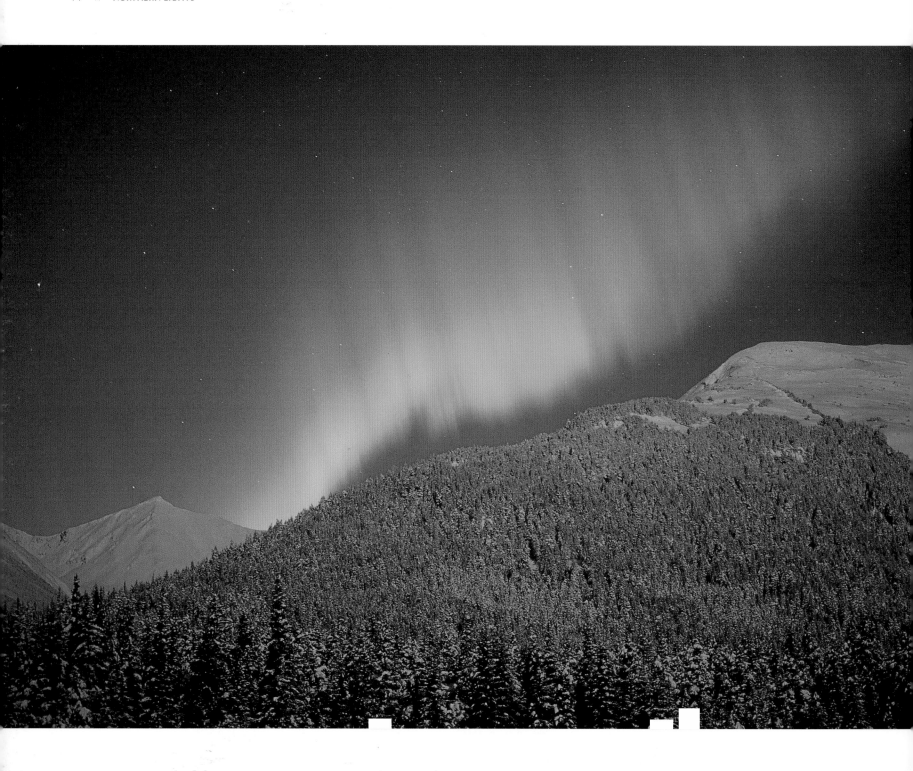

LEFT: *A full moon and bright aurora combine to give this ragged ridge a scenic luster. Ragged Top Mountain, Girdwood, Alaska (February).*

RIGHT: *This small pond near Palmer made a perfect reflection pool for these towering aurora (September).*

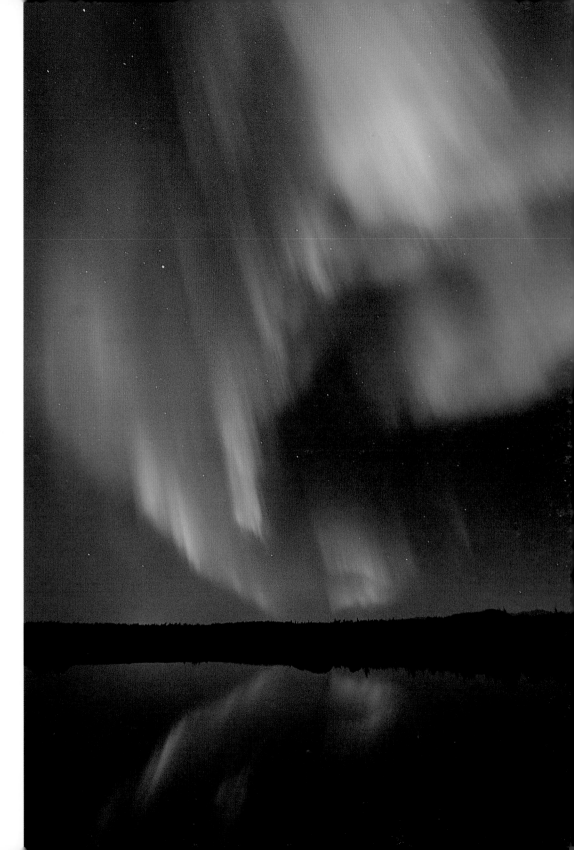

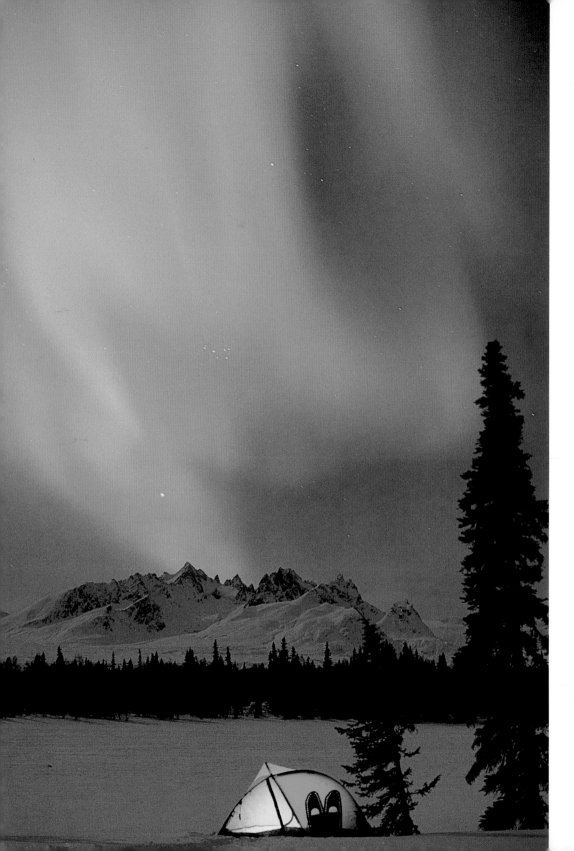

LEFT: *This camp was set up thirteen miles off the Parks Highway, facing the rugged and beautiful Tokosha Mountains on the south side of Mount McKinley in the Alaska Range.*

RIGHT: *A curved arc protrudes from Center Ridge on Mount Alyeska in Girdwood, Alaska. Coincidentally, this same geomagnetic display continued over Lillehammer, Norway, where Alaska skier Tommy Moe was earning gold and silver medals in the 1994 Winter Olympics.*

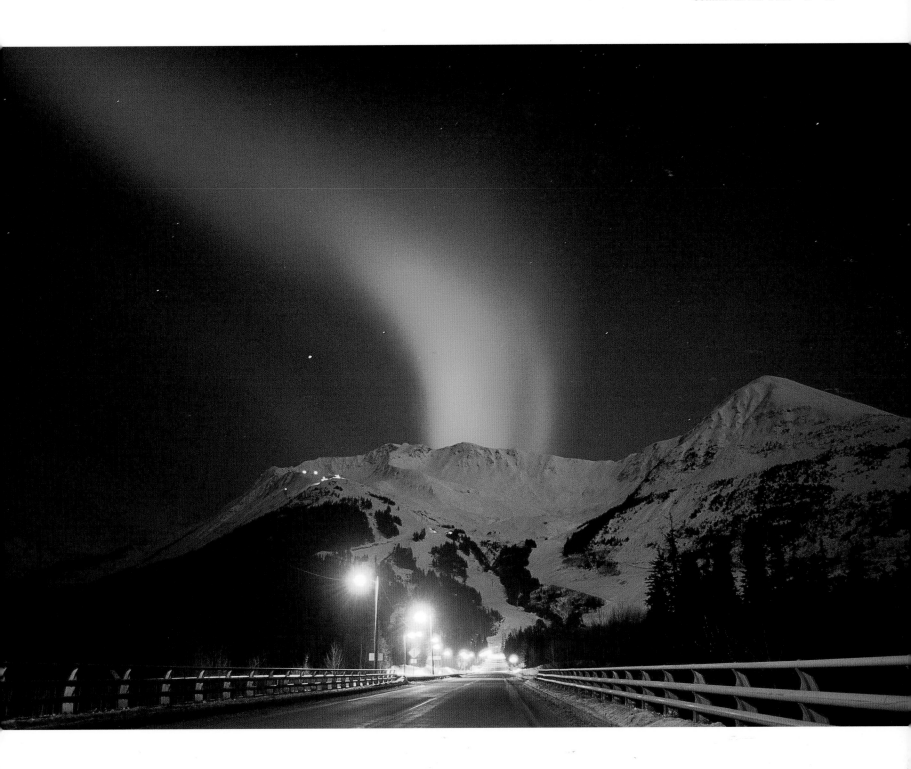

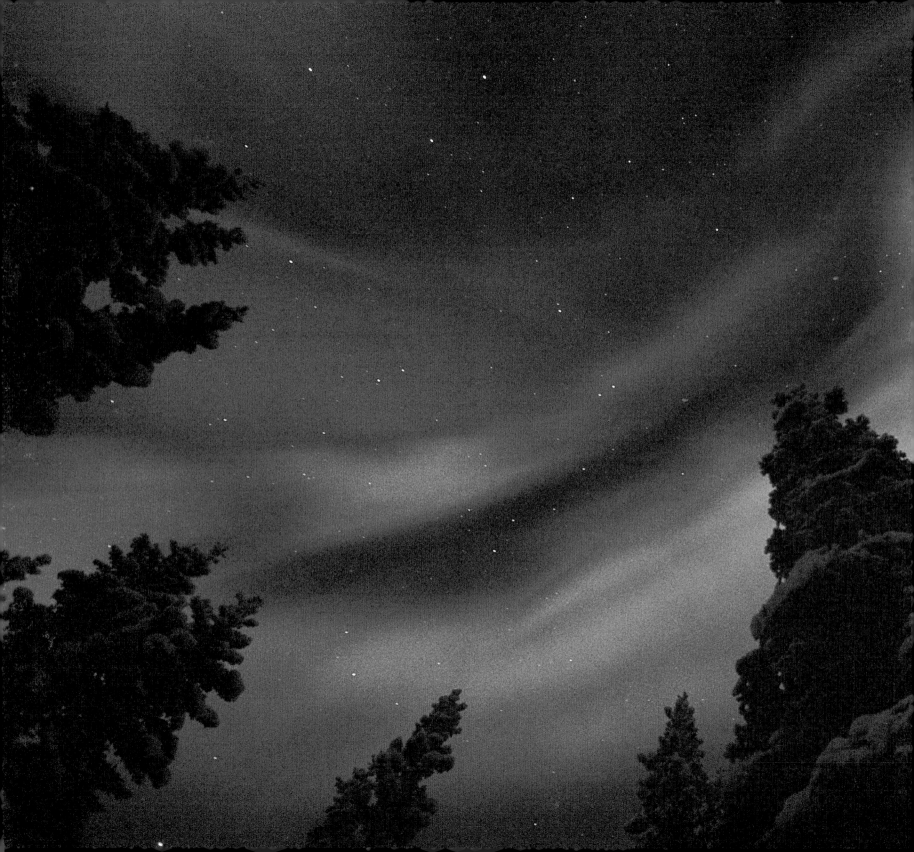

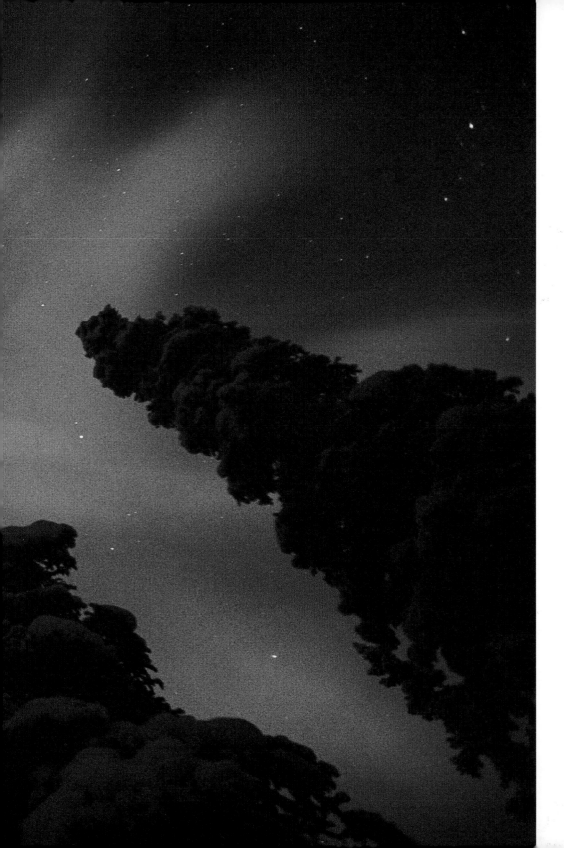

About 150 miles northeast of Anchorage on the Glenn Highway, this aurora flared up straight overhead. It was a moonless December night and the tall spruce trees created a dramatic effect.

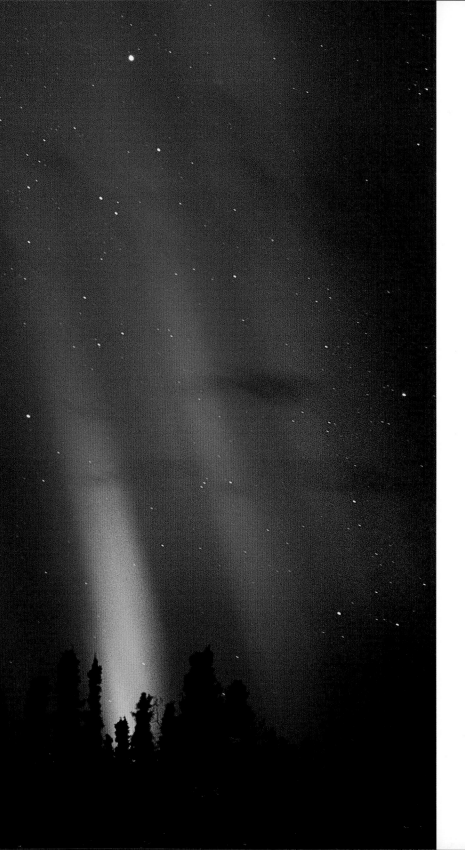

LEFT: *This is another image of the colorful and amazing auroral displays of April 6–7, 2000, near Willow.*

RIGHT: *Mount Redoubt volcano is dwarfed by this massive display above the western side of Cook Inlet (August).*

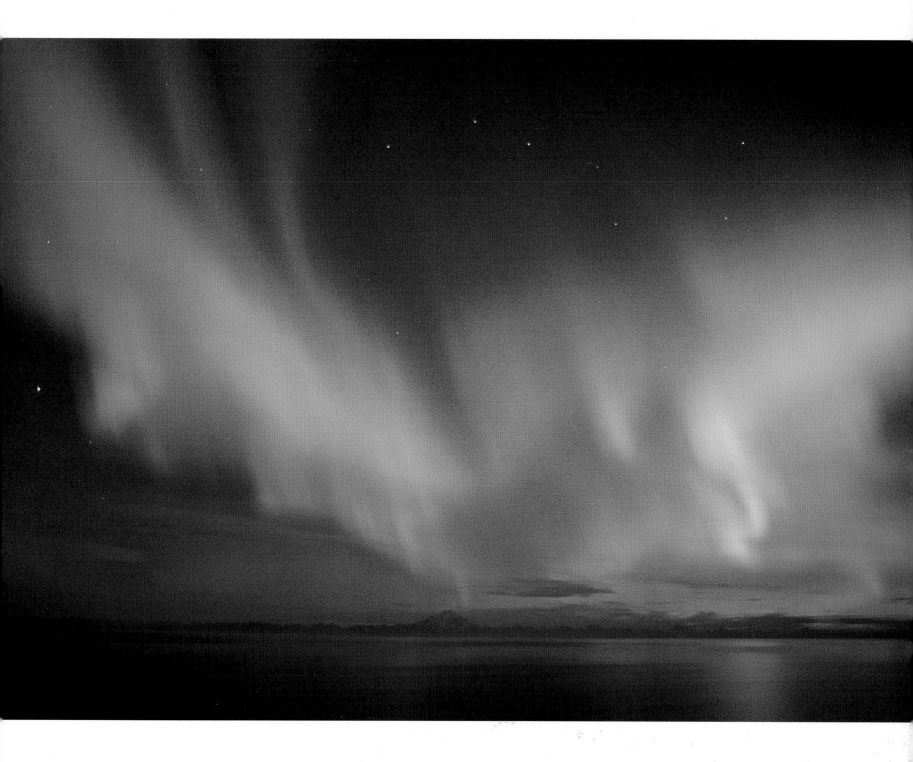

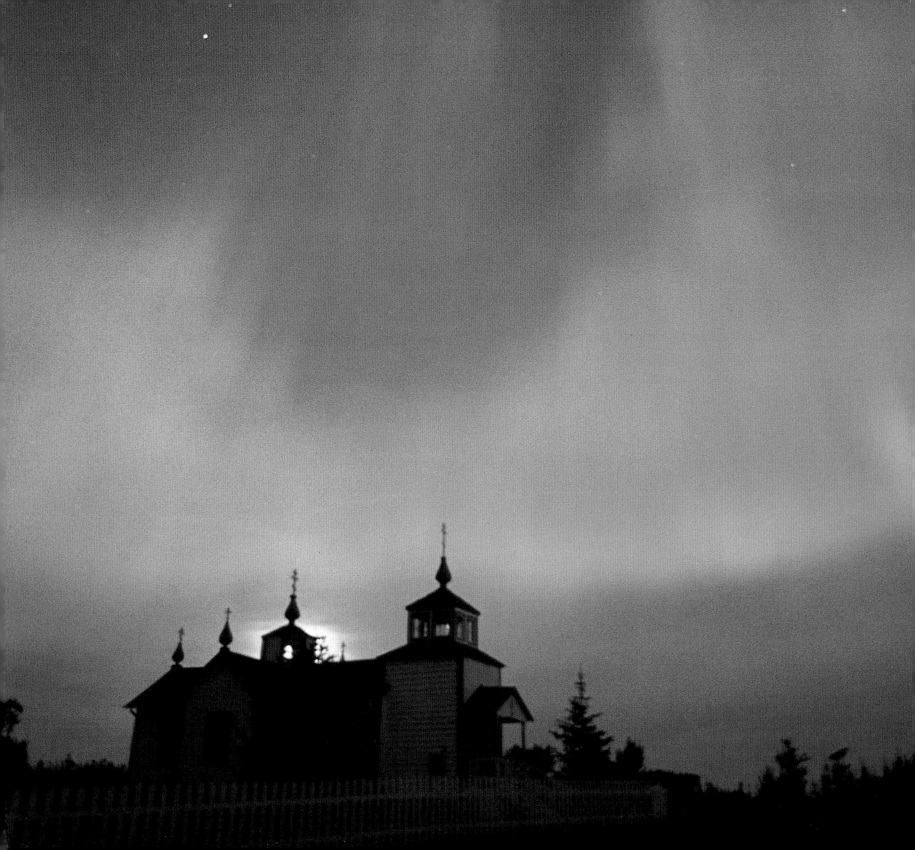

CRASH OF THE DC-4

The northern lights have often been mistaken for something they aren't.

After observing a rare aurora on the northern horizon, the Roman emperor Tiberius Caesar is

said to have dispatched his soldiers to help put out the "fire." A red aurora over London in

1938 had a similar effect: The fire department was mobilized when people thought Windsor

Castle was burning down. But what did two pilots flying an airliner across Alaska assume a

half century ago under a similar spell of the northern lights?

It was thirty-five below on the night Layton Bennett heard that a passenger plane may have just crashed on Mount Sanford in the remote Wrangell Mountains of eastern Alaska. Working in nearby Gulkana and owning his own plane, Bennett decided to launch his own rescue. It took a while to warm up the engine in his little two-seat Luscombe, but shortly before midnight on March 12, 1948, Bennett was airborne—squinting into the glare of the brightest aurora he'd ever seen.

The sky was cloudless that night, Bennett later told government investigators. Normally, he would have easily spotted Sanford's 16,237-foot summit, about forty miles east of Gulkana; the peak dominates the flat Copper River Basin like a pyramid in the desert. But the moon had already set, and the aurora was overpowering everything else in the darkness. Straight ahead—at least for periods of one to five minutes—he couldn't see anything but the northern lights.

"I'd been up in that area many times and I knew the mountains were there," says Bennett, now an eighty-two-year-old air-taxi operator in Southeast Alaska. "But absolutely you could not see the mountain. I don't know how it ever blanked out so badly. . . . I've seen thousands of auroras up here. I've been up here since '39 and it was just shimmering. . . . It was like looking into an oncoming car with its bright headlights on. It just blinded you."

By looking straight down, though, Bennett could see the aurora's reflected light in the Sanford River, which allowed him to navigate toward the mountain. "I knew I wasn't going to hit nothing, even though I couldn't see nothing. So I went up there making about half a dozen passes." He'd hoped to find signs of the crash and perhaps some survivors, but saw nothing except the aurora and the dark face of Sanford—and turned back home.

The next day, Bennett and several other pilots flew around the mountain to examine what had been impossible to see the night before. They found the spot where Northwest Airlines Flight 4422—a chartered DC-4 with twenty-four passengers and six crew members—slammed straight into the west face of Sanford at a cruising altitude of 11,000 feet. They saw the imprints of the plane's four engines that bored into the mountainside. They saw the charred trail the plane left after the fuselage exploded into a fireball—visible fifty miles away in Glennallen—then pinwheeled thousands of feet down an avalanche chute, rolling to a stop at the head of a glacier. They saw the snow slide that must have followed the plane downhill, burying all but a small portion of its tail section. They saw that no one could possibly have survived.

At the time, it was the worst airline crash in Alaska aviation history. What caused it? Was it the fault of the aurora? An investigation by the federal Civil Aeronautics Board (the

PREVIOUS PAGE: *The moon glows behind the century-old Russian Orthodox church in Ninilchik, Alaska, during the major storm of August 12, 2000.*

RIGHT: *The moon lit up the clouds and a few wet rocks on the beach, while this red and green aurora, viewed from west Anchorage, dazzled the sky over Cook Inlet (October 21–22, 1999).*

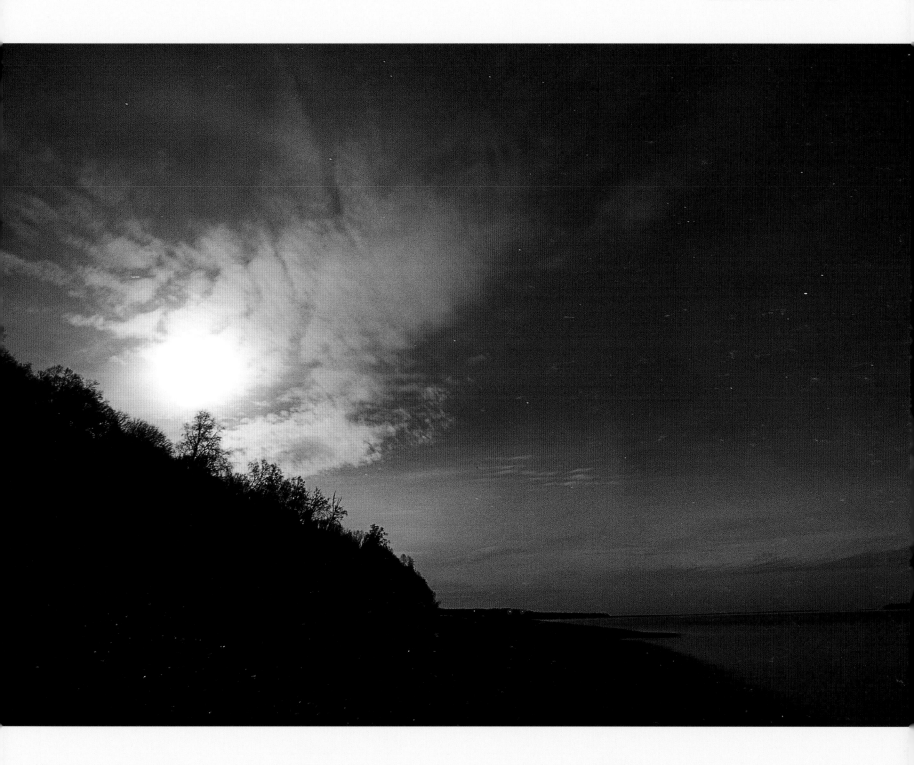

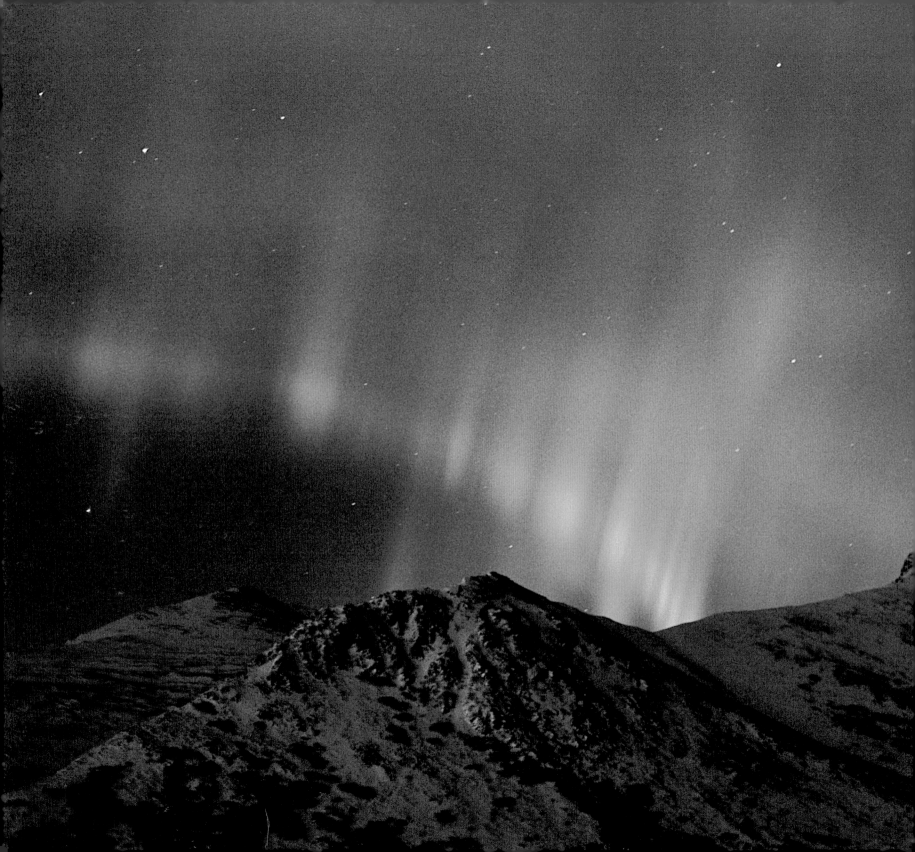

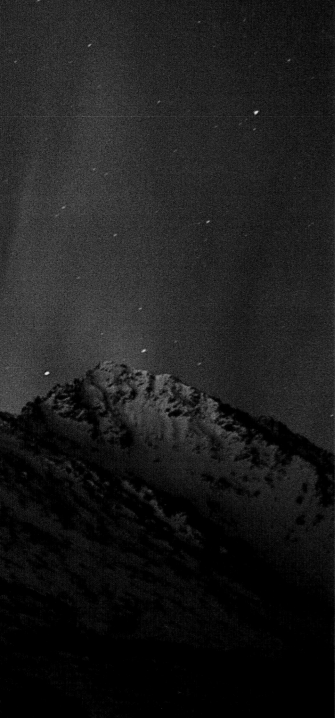

CAB, precursor to the National Transportation Safety Board) suggested that maybe it was. The pilot hadn't reported any problems when he radioed his position near Gulkana fifteen minutes before the crash occurred. Both pilot and copilot were familiar with the route. It appeared they had decided to "cut the corner" on Mount Sanford, trimming about twenty miles off the flight from Anchorage to Edmonton, rather than take the longer charted airway farther to the north. It was common for pilots to take the shortcut when conditions allowed. The captain of the DC-4 may have felt that the clear skies made that decision safe—only to be caught by surprise by the blinding aurora that Bennett talked about. Or perhaps there had been a thin cloud cover near Sanford's summit that the pilot confused with the aurora (though Bennett insists there wasn't).

The CAB was noncommittal in its official summary, concluding that "the probable cause of this accident was the pilot's failure to see Mount Sanford, which was probably obscured by clouds or the aurora borealis or both, while flying a course off the flyway." In most subsequent newspaper and magazine stories, however, the ambiguity was trimmed away: Simply put, the pilot had been blinded by the northern lights.

Today that assumption raises several questions, given our universe of new knowledge about auroras. First, is it really possible for the northern lights to "obscure" a 16,000-foot mountain, either by descending between the viewer and the mountain or by sheer brightness?

An aurora blocking your view isn't very likely, scientists say. The closest an aurora has ever approached Earth in more than a half century of photographic measurements and around-the-clock monitoring is about fifty miles higher than the cruising altitude of the latest jetliners. The tiny solar particles that power the northern lights simply cannot penetrate the lower regions of the ionosphere, where the air becomes more dense, let alone the even denser air of the stratosphere. In other words, the only way an aurora can intervene between a viewer and a mountain is for the viewer to take a long ride in a space module.

An aurora blinding someone with its brilliance is problematic too. Scientists have been studying the brightness of the northern lights for the past fifty years, and can safely say they aren't very bright. They've even created a four-step auroral light scale called the International Brightness Coefficient. The faintest auroras—rated IBC-I—emit about the

The lights of Anchorage illuminate the top of O'Malley Peak as the most common colored aurora forms an arc behind the ridge (mid-November).

same amount of light you see when you look at the Milky Way. Auroras rated IBC-2 are comparable to "thin moonlit cirrus clouds." Auroras rated IBC-III

compare to "moonlit cumulus clouds." And the brightest auroras ever measured—IBC-IV—provide "an illumination on the ground equivalent to full moonlight."

In other words, the brightest aurora is much less brilliant than looking directly at a full moon, according to Neil Davis, professor emeritus of geophysics at the University of Alaska in Fairbanks, which partly explains why you can see a full moon in broad daylight but you can't see the northern lights. ★★

★

From the vantage of his home near Gulkana, where he enjoys a clear view of Mount Sanford, Geoffrey Bleakley says he's highly skeptical that an aurora was bright enough to blind the pilots of Flight 4422. "I see the northern lights a lot," says Bleakley, the historian for Wrangell–St. Elias National Park, "and the northern lights have never kept me from seeing the mountain clearly."

In winter when it's cold and clear and Sanford is covered in a fresh mantle of snow, even on moonless nights Bleakley can still see the peak some forty miles away, rising about 14,000 feet higher than Gulkana. He sees it even better when there's an aurora out, he says, especially when the northern lights swing behind the mountain, sharpening its silhouette by contrast. He doesn't doubt that the aurora Layton Bennett saw around midnight on the night of the crash was as bright as Bennett says. But he points out that auroras change minute by minute, in both their intensity and their position in the sky—and that an aurora at nine o'clock bears no relation to one that occurs at twelve. Says Bleakley, "If someone reported spectacular northern lights three hours after [the crash], that means nothing."

Few people alive today have pondered the fate of the Northwest Airlines passengers and crew as much as commercial airline pilot Marc Millican of Anchorage. A Northwest Airlines pilot himself, Millican sees the northern lights fairly often while flying passenger jets between Alaska and the Lower 48.

"If you're really into the aurora borealis," he says, "you've got to get up to 35,000 feet and experience it there—just because it's so big. It's enormous."

Millican can easily imagine how the pilot of Flight 4422 may have battled the brightness, flying near mountaintops. "When I'm up at 35,000 feet, I'm almost looking directly at the borealis from a horizon I'm on. And I can't see the mountains down below. At all. Because it's blinding me—it's very bright."

Layton Bennett has his own opinion. He thinks the pilots simply weren't watching. He thinks they put the aircraft on autopilot in the doldrums of a long night flight, assuming

THE MAKAH INDIANS OF THE PACIFIC NORTHWEST THOUGHT THE LIGHTS WERE THE REFLECTION OF FIRES THAT THE PEOPLE OF THE FAR NORTH LIT TO BOIL BIG POTS OF WHALE BLUBBER.

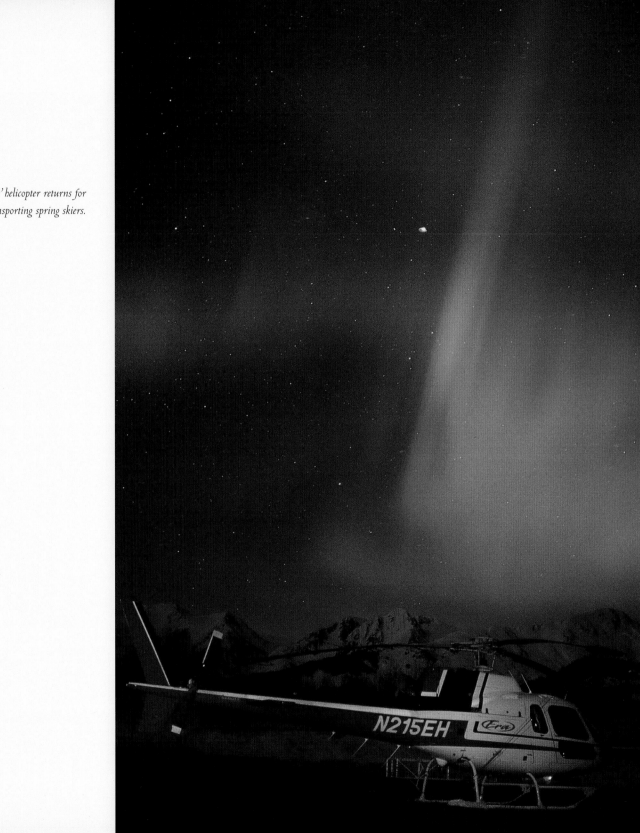

The Chugach Powder Guides' helicopter returns for a rest after a long day of transporting spring skiers.

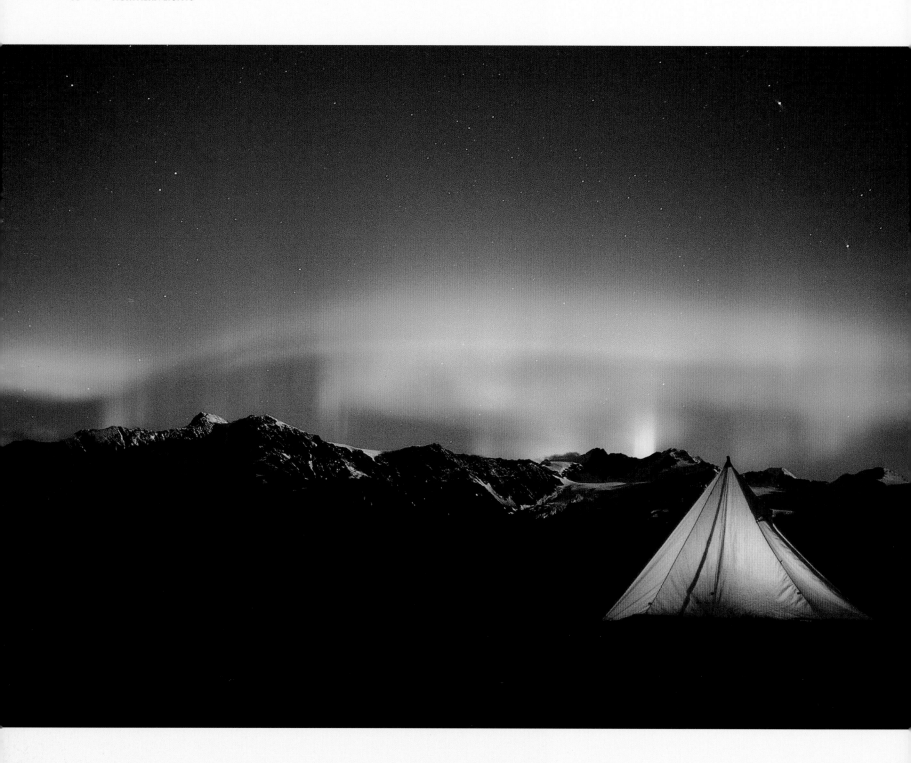

This angle atop Mount Alyeska provides an awesome panoramic view of the Chugach Mountains with aurora (late August).

they were on a safe heading, and left the cockpit temporarily, or dozed off, or gazed out the port-side window at an aurora on the northern horizon while the plane was heading east. It's the kind of speculation that accident investigators are loath to make, since there's no way to prove it.

"It was such a beautiful night," Bennett says. "I betcha what they did is say, 'Gosh, it's clear. We can see everything. We'll just make a beeline. . . .'"

After the crash, the crumpled fuselage of Flight 4422 became buried in an unnamed glacier that winds down the west face of Mount Sanford. Signs of the wreckage disappeared beneath the ice and snow, frustrating subsequent search parties that continued to trek to Sanford for years afterward (encouraged by rumors that there may have been gold or some other treasure aboard the plane).

About fifty years after the crash, however, two men—Millican and fellow airline pilot Kevin McGregor—found portions of the wreckage that churned to the surface of the glacier about five miles below the crash site. They weren't looking for treasure, the men told reporters. Nor did they find any. They only wanted to preserve what they consider to be historical artifacts—and passed on what they found to Bleakley, the historian of Wrangell–St. Elias National Park.

In the meantime, the jumble of rocks and ice of the glacial moraine that presently holds the wreckage of Flight 4422 continues to churn. "It's constantly shifting and things are becoming uncovered and recovered on a daily basis," Bleakley says. "It's probably got, maybe, another fifty years before it all starts coming out at the end."

Then perhaps some of the mystery of Flight 4422 may be answered. But not so easily the mystery of the aurora.

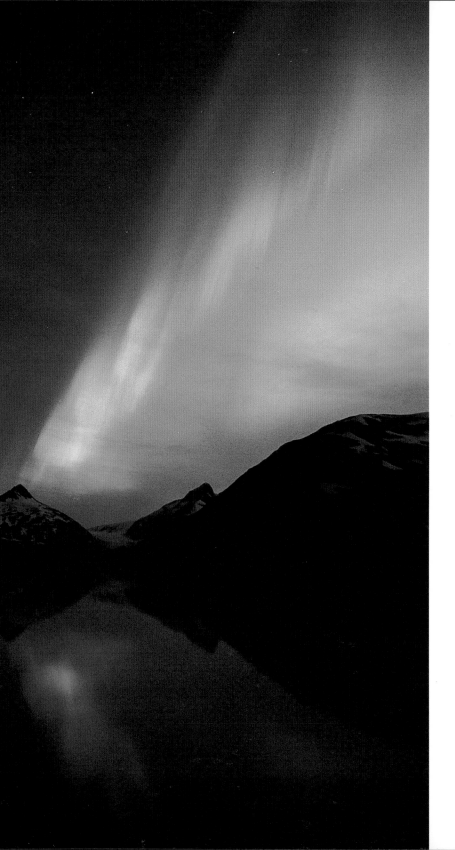

LEFT: *Portage Lake reflects a wonderful and colorful aurora over Bard Peak (August 12, 2000). Many people mistakenly assume it must be cold to see the northern lights. Not so. But it must be dark and clear and, in Alaska, that normally means cold.*

RIGHT: *A driver heads down Hatcher Pass Road in the moonlit Talkeetna Mountains, just as the northern lights brighten (late February).*

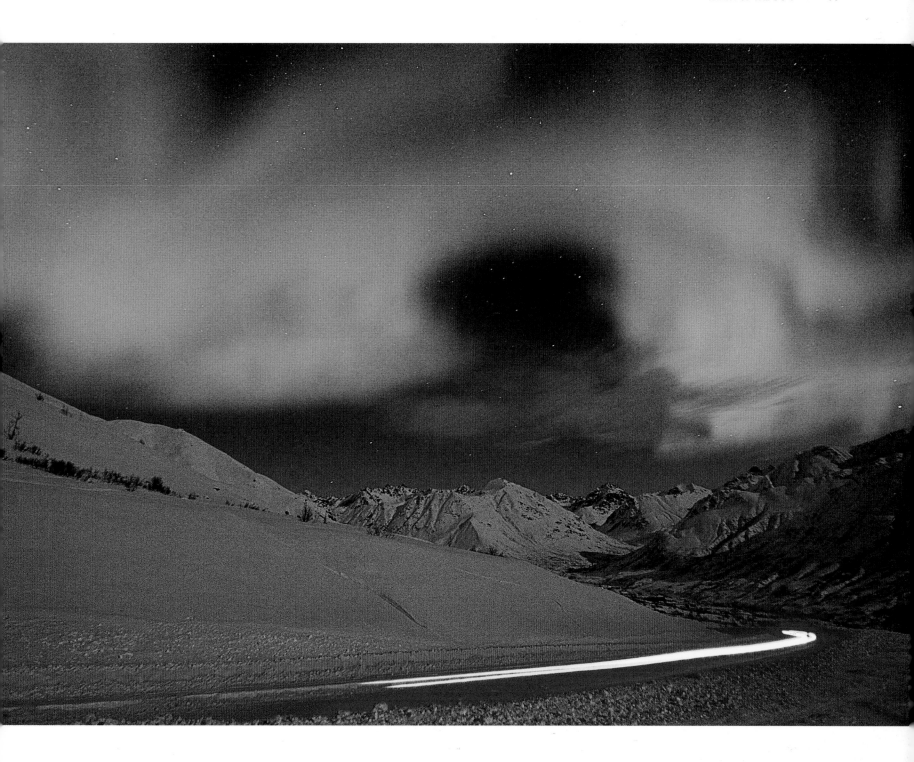

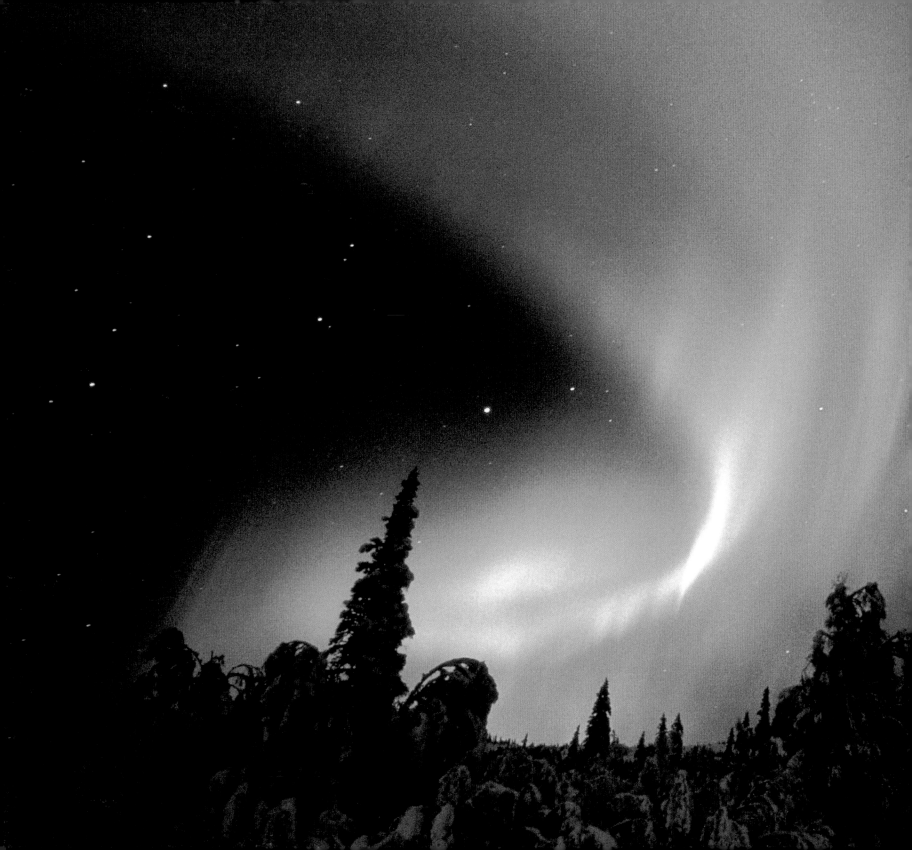

The flow and scale of this beautiful display at mile 135 on the Parks Highway southeast of Mount McKinley welcomed in a cold New Year.

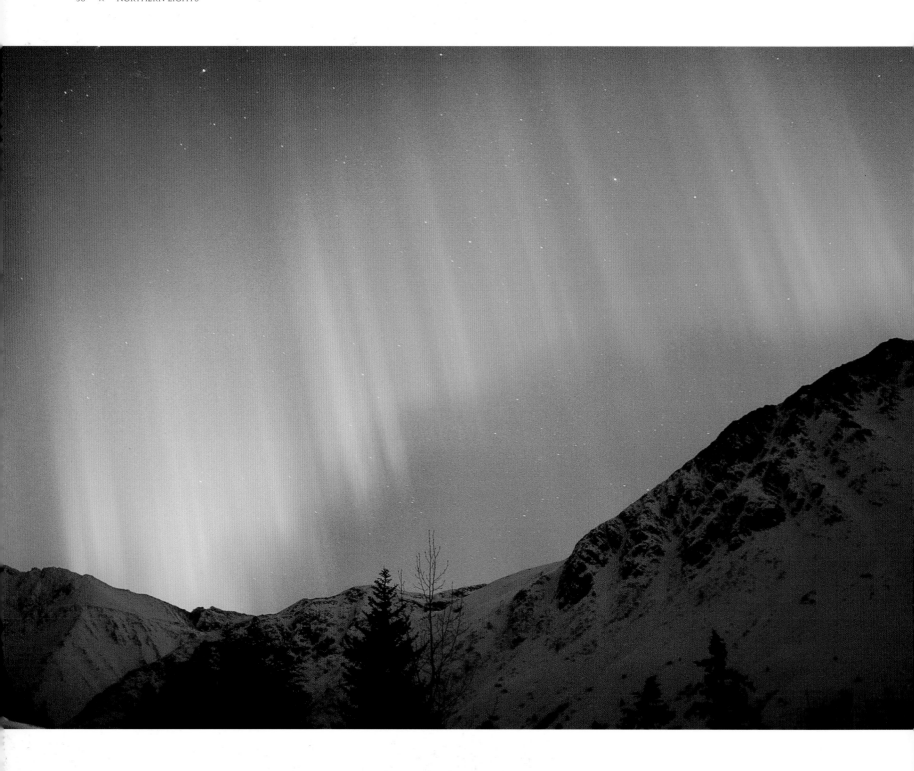

LEFT: *Sharp rays burn brightly over Crow Pass between Eagle River and Girdwood (March).*

RIGHT: *One of the original Colony Barns in Palmer, Alaska (April).*

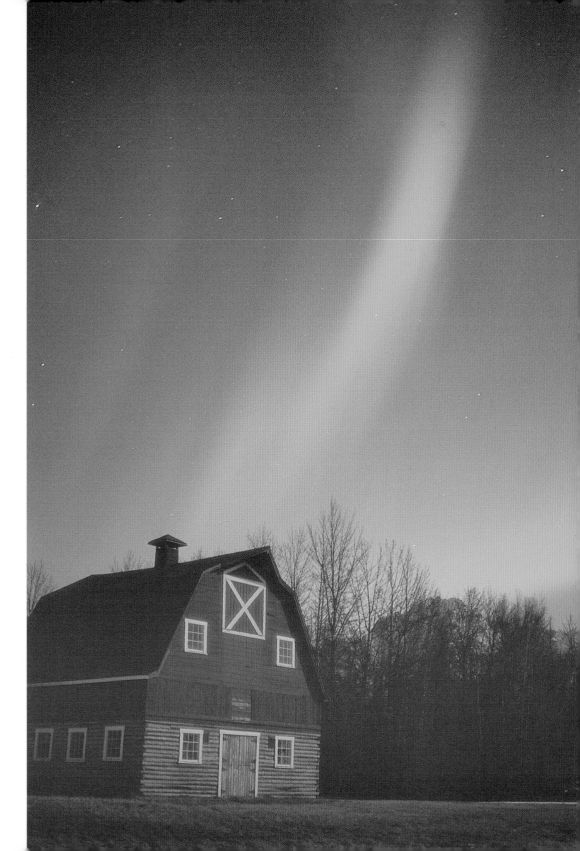

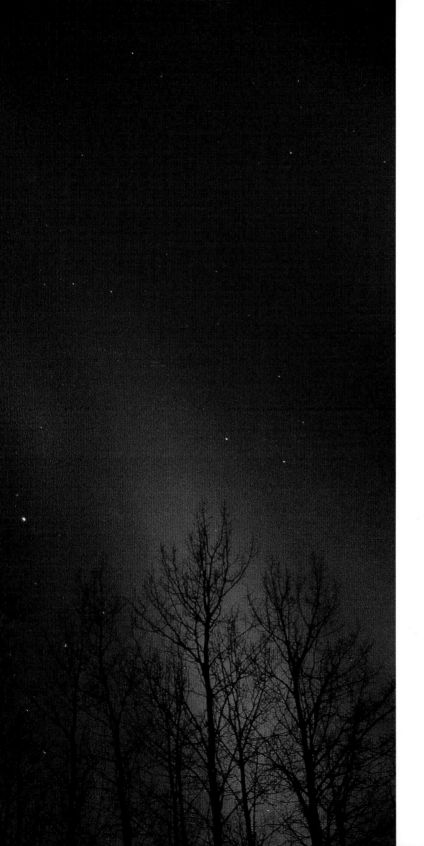

LEFT: *This phenomenal and rare red display was captured in Fairbanks, but was seen as far south as Texas and Key West, Florida (November 8–9, 1991).*

RIGHT: *Red Dawn: As the sun rises, red auroral curtains give way to the growing daylight.*

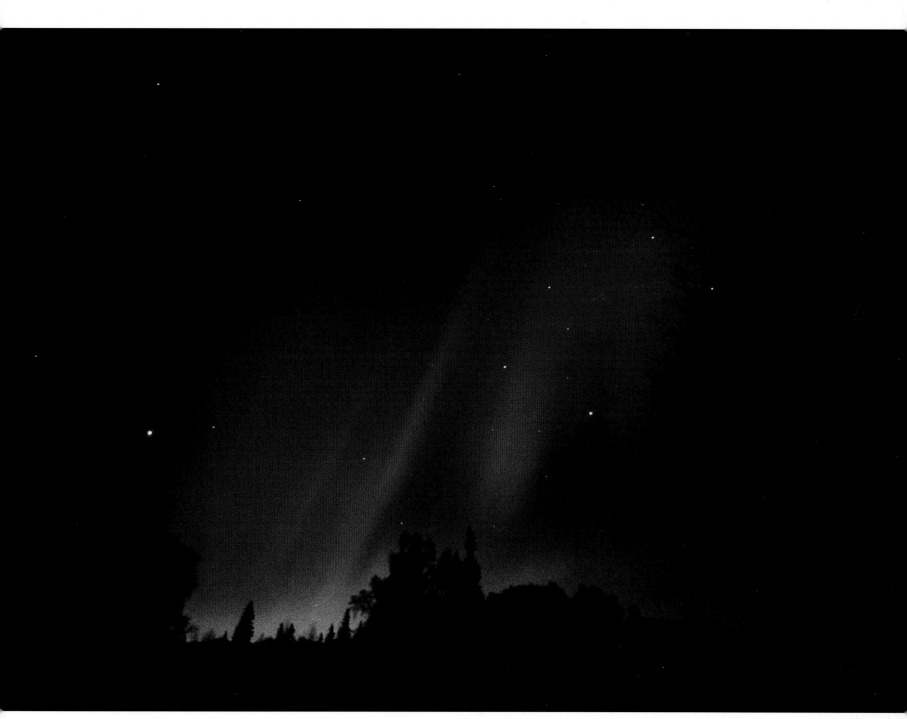

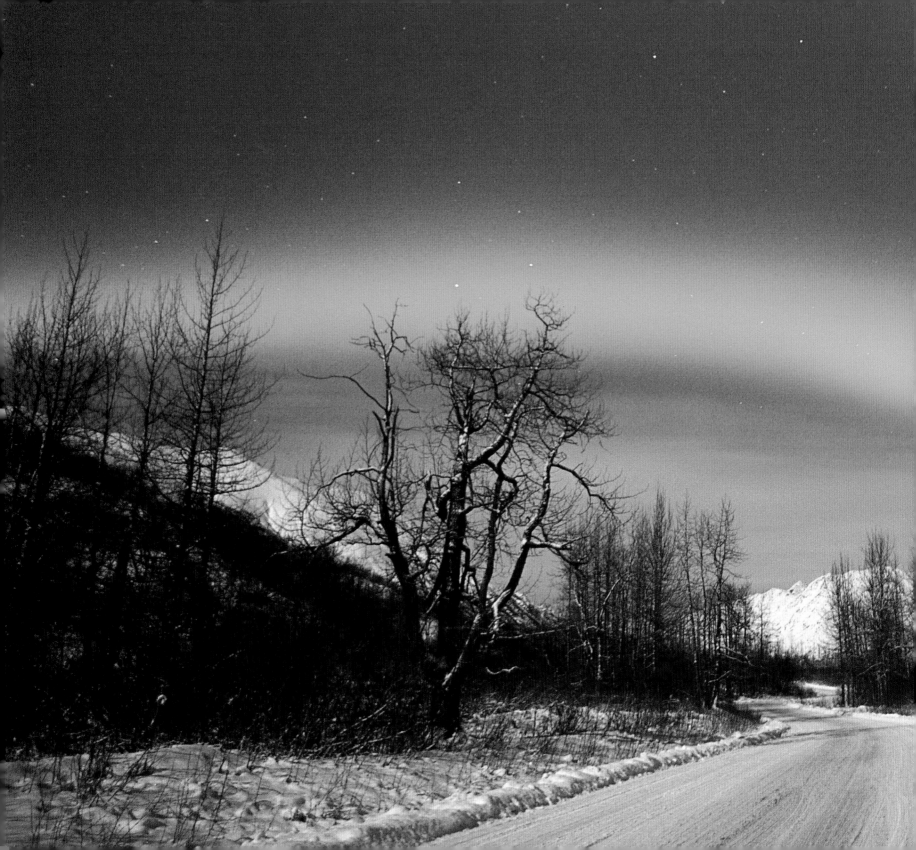

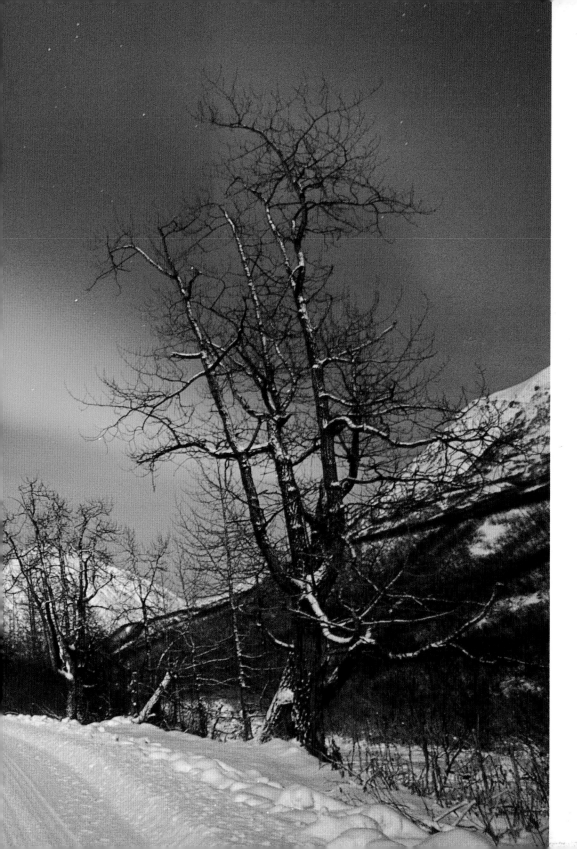

Although Anchorage was covered in pea-soup fog, the view from Hatcher Pass Road in the Talkeetna Mountains revealed a bright moonlit night (mid-December).

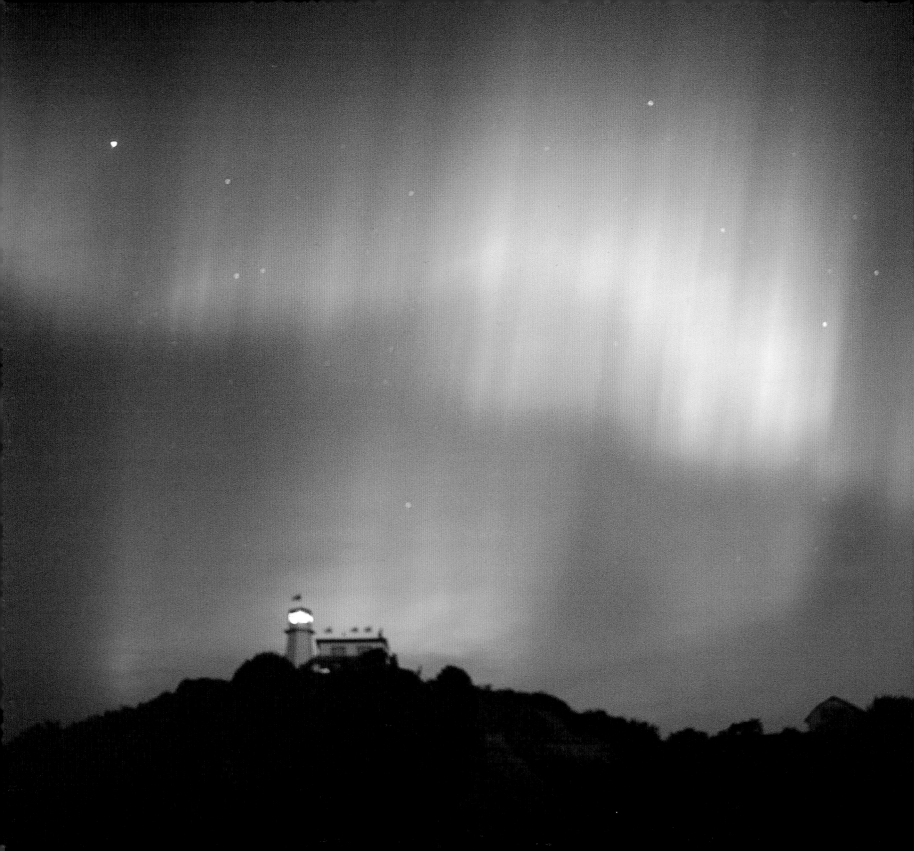

THE ONCE AND FUTURE AURORA

The night began on a home computer. Alaskan photographer Daryl Pederson sat

down at his desk and logged onto the Internet. From his home in Girdwood, a turn-of-the-century

gold mining town transformed into a turn-of-the-new-century ski village, about forty miles

southeast of Anchorage, he was suddenly transported far into space.

Depending on the website he chose from a long list of bookmarked favorites, Pederson could

easily examine the Sun. Not in the sense of walking outside and looking up;

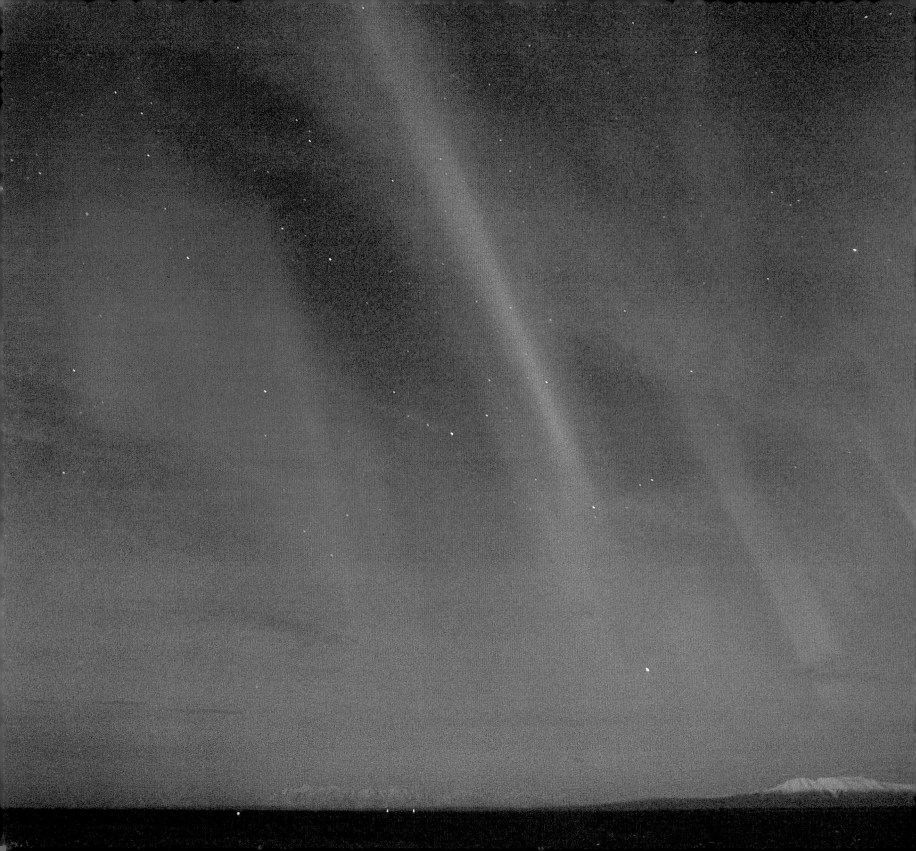

PREVIOUS PAGE: *The beacon at Northern Light House in Ninilchik, Alaska (September).*

LEFT: *Here, the northern lights were in the southern sky all night over Cook Inlet with Mount Susitna, known as "the Sleeping Lady," to the right (mid-October).*

Pederson could get much closer. He could pull up a color image of the solar disk, photographed every ten minutes by an observatory in Hawaii, and squint at the number and density of sunspots. He could look for the telltale bundling of spots that signals a solar flare. He could speculate on its direction: If the flare was positioned just right, it might send a storm of charged particles hurtling toward Earth. The light from the explosion would make the 93-million-mile journey in eight seconds flat. But even a strong solar wind racing a million miles an hour would require more than three days to cover the same distance.

Just before the aurora was scheduled to arrive, Pederson's habit was to log onto his computer and check the final solar-wind data relayed to Earth by a satellite stationed about a million miles away. The orbiter could tell him (or any other aurora watcher with access to the Internet) the exact speed and density of electrons in the approaching storm about an hour before it reached the ionosphere. It could also tell him the direction of the Interplanetary Magnetic Field (the Sun's magnetic field) that the charged particles towed with them toward Earth. A solar-wind speed over 800,000 miles per hour was promising, but the IMF had to be trending south for an aurora to appear.

On the night of April 6, 2000, Pederson stared at his computer for clues. Two days earlier, a "coronal mass ejection" had exploded from the Sun, sending a wave of ionized gas rushing toward Earth at especially high speed. It was expected to arrive that evening. Pederson rechecked the magnetic orientation of the storm, then picked up his phone and called Calvin Hall, a fellow photographer based in Anchorage. "It's going to go tonight," Pederson said. "It's going to go *big.*"

But if an aurora goes big and no one sees it. . . .

That's always the question for aurora photographers—especially around Anchorage, where cloudy skies could completely conceal a spectacular light show. Now it was Hall's turn to spring into action. From his better vantage near an ocean bluff in West Anchorage, the photographer and avid aurora hunter could scout the cloud cover in a lot of different directions. He could see that this was a night to drive north.

No, this was not your grandfather's aurora. The wild marriage between the space age and the computer age that capped the twentieth century had taken auroral science so far so fast, it was hard to even remember the 1950s—let alone the 1900s, when the modern era began.

You could track the maturation of auroral physics in a clear line from the breakthrough research of Norwegian physicist Kristian Birkeland in the early 1900s, to British physicist

Sydney Chapman in the 1930s and '40s, to Japanese-American physicist Syun-Ichi Akasofu in the 1960s and '70s.

Birkeland was the first aurora scientist to propose a unified theory that included all the parts of the aurora puzzle: charged particles from the Sun, powerful forces in the Earth's magnetic field, upper atmospheric gas, an electrical discharge. That's why there were always electrical currents on the ground associated with a strong aurora, he said. Not because of electricity falling from the sky—but rather because the electron stream from the Sun disturbed the Earth's magnetic field, causing it to move, and as the magnetic field moved near the ground through any conductor, it generated new electricity.

Birkeland's theory had a few holes in it, which other aurora scientists weren't shy about pointing out. "How could these electrons from the Sun ever reach Earth?" they asked. "All electrons have a negative charge—wouldn't they repel each other and dissipate?" This was a good point, and Birkeland didn't have an answer.

But Chapman and a colleague eventually did, in 1933, introducing a new principle of astrophysics in the process. It wasn't electrons alone that poured from the Sun, Chapman said. It was extremely hot, ionized gas (now called "plasma"), consisting of free electrons and protons existing together in a collectively neutral state. It was this "fourth state of matter" that allowed the electrons to congregate. Scientists today explain it this way: You heat a solid, it becomes liquid. You heat a liquid, it becomes gas. You heat a gas at extremely high temperatures—the upper atmosphere of the Sun reaches 1 million degrees centigrade—and it turns to plasma, which accounts for 99 percent of the universe (since all the other stars are generating plasma too).

Chapman also discovered the true nature of the magnetosphere that protects the Earth from the destructive power of plasma. The magnetosphere begins near the lower altitude of the ionosphere, some sixty miles above sea level. At that elevation, the Earth's magnetic field is relatively undisturbed and resembles the lobed shape of an apple—just as earlier scientists said it did. But the outer edge of the magnetosphere wages a constant battle against the solar wind, which sculpts it into the shape of a comet's tail millions of miles long.

Swedish physicist Hannes Alfven then explained how some of the solar particles are able to enter the "comet's tail" and power the aurora. Just as some of the river water that flows past a boulder circles back upstream in an eddy, some of the electrons and protons in the solar wind circle back inside the tail of the magnetosphere—where they're quickly snapped down to Earth by magnetic attraction. Journeying both outside and inside the magnetosphere, solar electrons cut across magnetic-field lines in a way that generates about

A lasso of light encircles the sky as seen from the Denali Overlook at mile 134 of the Parks Highway.

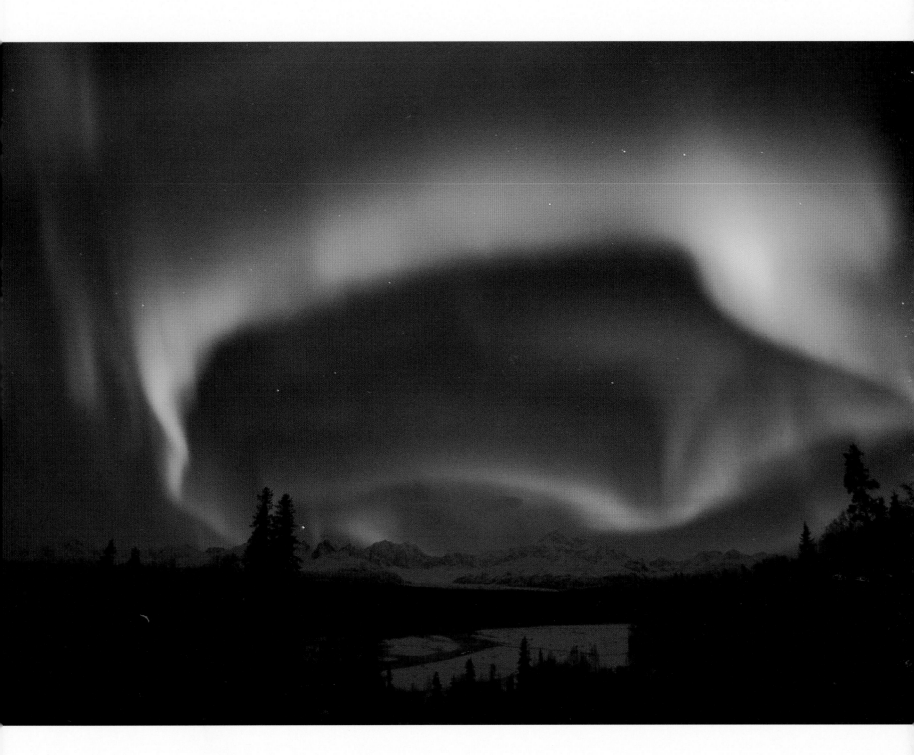

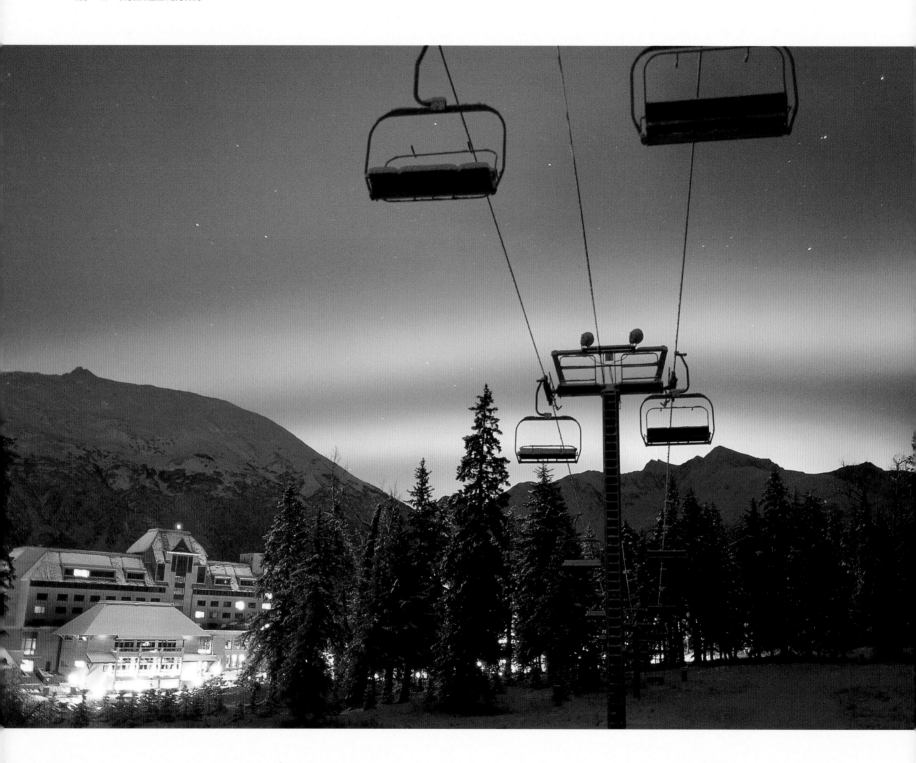

1,000 billion watts of upper atmospheric electricity.

Aurora-related electrical currents heating the upper atmosphere, in fact, played particular havoc with long-distance radio transmissions during World War II, prompting some of the world's military powers to learn more about auroras. After the war, Congress established the Geophysical Institute at the University of Alaska in Fairbanks to research Arctic radio communications in particular and auroras in general. Chapman moved to Fairbanks in 1953 to serve as the institute's first director of science.

The Alyeska Prince Hotel may be the only ski resort that offers a northern lights wake-up call!

Four years later, Chapman encouraged thousands of physicists around the world to join the International Geophysical Year, working in teams to take pictures and gather voluminous records of the aurora in both the Northern and Southern Hemispheres. One of the participants was Akasofu, who moved from Japan to Alaska to help Chapman make sense of all the data. That same year, 1957, the Russians launched *Sputnik,* the world's first satellite.

Older Americans may still recall the wonder of looking overhead that October and spotting the little Russian space module orbiting the Earth every ninety-six minutes—though they may never have known that, among other mission goals, what *Sputnik* was doing in the ionosphere was sweeping up aurora-related data about space particles, magnetic-field lines, temperatures, and radiation. A short while later, America countered by launching its *Explorer* satellite, and the space race was on.

A U.S. astronaut would walk on the Moon before the end of the next decade. Along the way, U.S. satellite missions would validate much of what Birkeland, Chapman, and Alfven had said earlier in the century about auroras and the relationship between Earth and Sun. Photographs from space would validate some of Akasofu's controversial discoveries as well.

As a member of a team taking simultaneous "all-sky" photographs in two jet aircraft, one flying over Alaska and the other over New Zealand, Akasofu, along with others, was able to show that the aurora borealis and the aurora australis are essentially mirror images of each other, bound by the same magnetic-field lines. He showed that the neatly symmetrical "auroral zone" that physicists had long included in their textbooks was really a lopsided "auroral oval" around the magnetic North Pole, which explains why northern lights usually appear first on the northern horizon, regardless of latitude. He showed that auroral substorms—the rise and fall of an auroral sequence on any given night—could occur two or three times a night, and that they weren't simply a function of the time of night or the Earth's rotation but something else, yet to be understood.

There's a lot he still doesn't understand about the northern lights, says Akasofu, who followed Chapman as director of the Geophysical Institute. "Do not forget that nature is

infinitely complicated," he once wrote. "Never have an illusion that one will ever have a complete understanding of it."

The nature of the plasma that powers the northern lights needs to be studied much more, Akasofu says. It might one day unlock the mystery of nuclear fusion, providing a safe and inexhaustible form of power. It might tell us how to explore new worlds, since the universe is almost entirely plasma.

Right now, what we already know about auroras and plasma could possibly tell us whether there's life on other planets. Many planets besides Earth have auroras, including other planets in our own solar system. If we find a distant world whose aurora emits the same wavelength of greenish-white light that serves as a signature for atomic oxygen, then perhaps we'll find life forms associated with oxygen too.

There's a famous scene in *The Graduate* in which Benjamin Braddock (played by Dustin Hoffman) is buttonholed during his own college graduation party by one of his parent's friends. "I just want to say one word to you," the man says, staring straight into the graduate's eyes. "Just one word."

"Yes, sir," says Benjamin uneasily, returning his gaze.

"Are you listening?"

"Yes, sir, I am."

"Plastics," says the man.

Maybe today we should tell our graduates, "Plasma."

The Iditarod was over. The spring equinox had come and gone. With daylight prevailing once more, the usual eight-month aurora-viewing season in Alaska was nearly past. By early April, some people thought it *was* past. They thought it needed to be clear and cold for the lights to appear, but of course they had it only half right. Huge solar winds could occur any month of the year, and it didn't have to be clear for people to feel their power. The five biggest geomagnetic storms of the past half century had spread evenly across the calendar: February (1958), March (1989), July (1958), August (1972), December (1980).

The northern lights of March 13 and 14, 1989, were a powerful example. They blew in as a 10-million-miles-per-hour solar hurricane that painted a blood-red aurora over most of the Lower 48. The magnetic storm burned up the transformer of a nuclear power plant on the Delaware River and knocked out all the power in the province of Quebec.

Nothing quite so dramatic was anticipated for the evening of April 6, 2000. Still,

NINETEENTH-CENTURY SCHOLAR ALFRED ANGOT ABOUT PERCEPTIONS OF AURORAS IN THE 1500S: "AT THE SIGHT OF THEM PEOPLE FAINTED . . . OTHERS WENT MAD. PILGRIMAGES WERE ORGANISED TO AVERT THE WRATH OF HEAVEN MANIFESTED BY THESE TERRIBLE SIGNS."

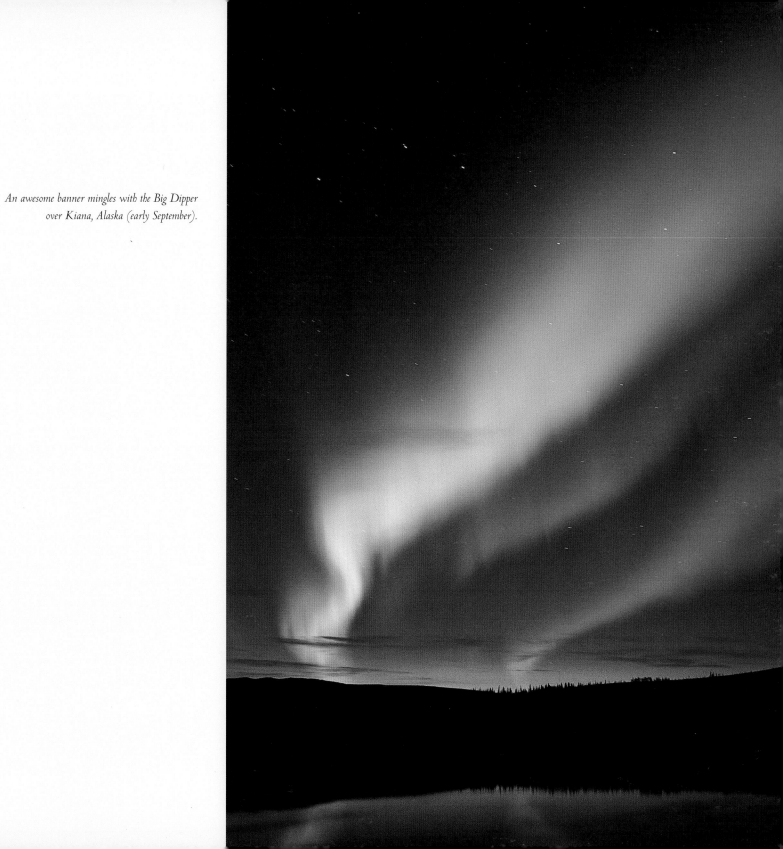

An awesome banner mingles with the Big Dipper over Kiana, Alaska (early September).

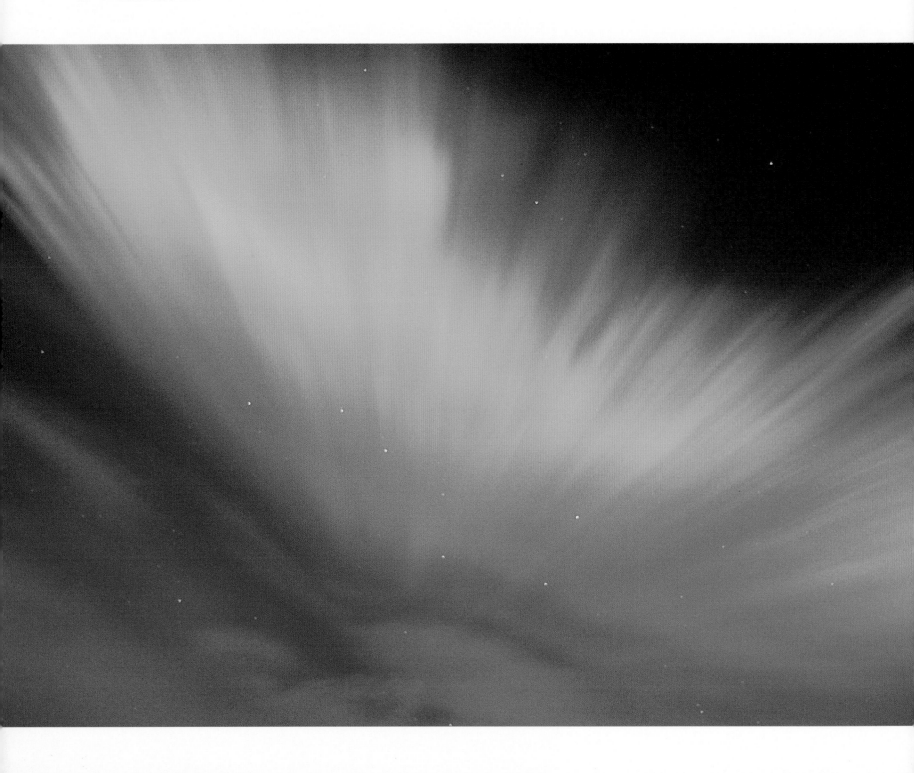

This 3:00 am activity was unexpected and short-lived, but the intensity was spectacular, creating this bright corona over the Kenai Peninsula (February).

power companies all across the northern-tier states were taking precautions. A big solar wind had already entered the upper atmosphere, and satellites that monitor the circumpolar auroral oval were showing a huge bulge that sagged as far south as North Dakota. As the world turned, the bulge rotated west toward British Columbia. Over Seattle, with any luck, the weather would be clear and the lights would be prime.

Up in Anchorage, however, there was no such luck. A low-pressure system had arrived by early evening, and an aurora watcher had to look hard to find a hole in the clouds. Still, there were holes.

Daryl Pederson thought he'd found one about thirty miles north of town along the Knik River. He'd set up his tripod and pointed his camera at 4,326-foot Mount Susitna—"Sleeping Lady"—inclining to the west. With any luck, he thought, a long, shimmering, green curtain might arch from east to west right over her snow-covered bed. Pederson turned his attention north and waited.

But the lights never came from the north that night. They were already far advanced to the south, and a cloud bank to the south was right in Pederson's line of sight. He could see an aurora shimmering just beyond it. He needed to get higher fast.

Stowing his gear, Pederson jumped into his van and began driving up the Old Glenn Highway. By the time he reached Pioneer Peak, the lights had begun to explode. He set up his tripod on the side of the road to take pictures as best he could, but his position was still compromised by clouds. "Why didn't I go farther north?" he asked himself. There just wasn't enough time.

Having started the night farther north than Pederson, Calvin Hall had time to drive to Willow, about eighty miles north of Anchorage. He set up his camera far down a dead-end road beyond the lights of any cabin. Then he began to wait.

For a photographer of the northern lights, waiting becomes a way of life. The lights don't follow a schedule (Internet or no Internet). You have to be patient and you have to persevere—the whole subzero night long if necessary. Some nights Hall has sat bundled and alert in some empty expanse of snow from dusk until daybreak, all to no avail. Sometimes the lights have appeared after he's lost all hope.

Once in the past, north of Fairbanks, Hall had had reason to expect a spectacular display. It's an aurora watcher's rule of thumb that one good night is usually followed by another. The night before, he'd seen a brilliant red aurora over Fairbanks early in the evening, but the whole display had dissipated before he could escape the lights of town. The next night he started out at six in the evening and drove thirty miles north to a perfect

location. He could see everywhere. But the lights didn't appear early, as they had the night before—or anytime soon.

"Nothing," Hall recalls. "Seven (o'clock) . . . eight . . . nine . . . ten . . . eleven . . . twelve . . . one . . . two . . . nothing."

Or almost nothing. About two in the morning, he got "a little bit of wimpy northern lights." It was so underwhelming, so discouraging, he nearly drove home that instant. But he didn't.

"About two-fifteen—they went nuts. They were phenomenal! I could see bands twisting and turning way, way off to the northwest and northeast and different displays that I had never seen before."

So there was good reason to wait on this April night in Willow too. Around eleven o'clock, his perseverance finally paid off.

The display began as a brilliant red glow in the southeast. "Then you could see some yellows trying to come in," Hall recalls. "Then about three minutes later, it shifted from magentas to more yellow. Then to more and more yellow. Then *orange!*"

Before the night was through, Calvin Hall would witness—and photograph—the richest, reddest aurora he'd ever seen in his entire life. An aurora capable of striking fear in the hearts of medieval Europeans. Then the season of the northern lights would suddenly end. A season to remember.

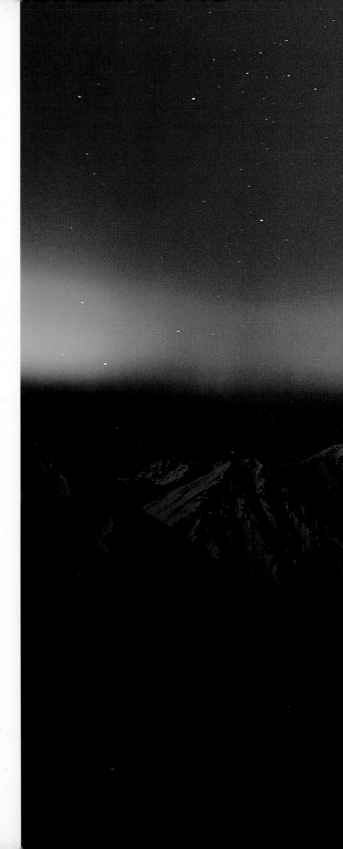

Goat Mountain in the Girdwood Bowl,
with a spring aurora display.

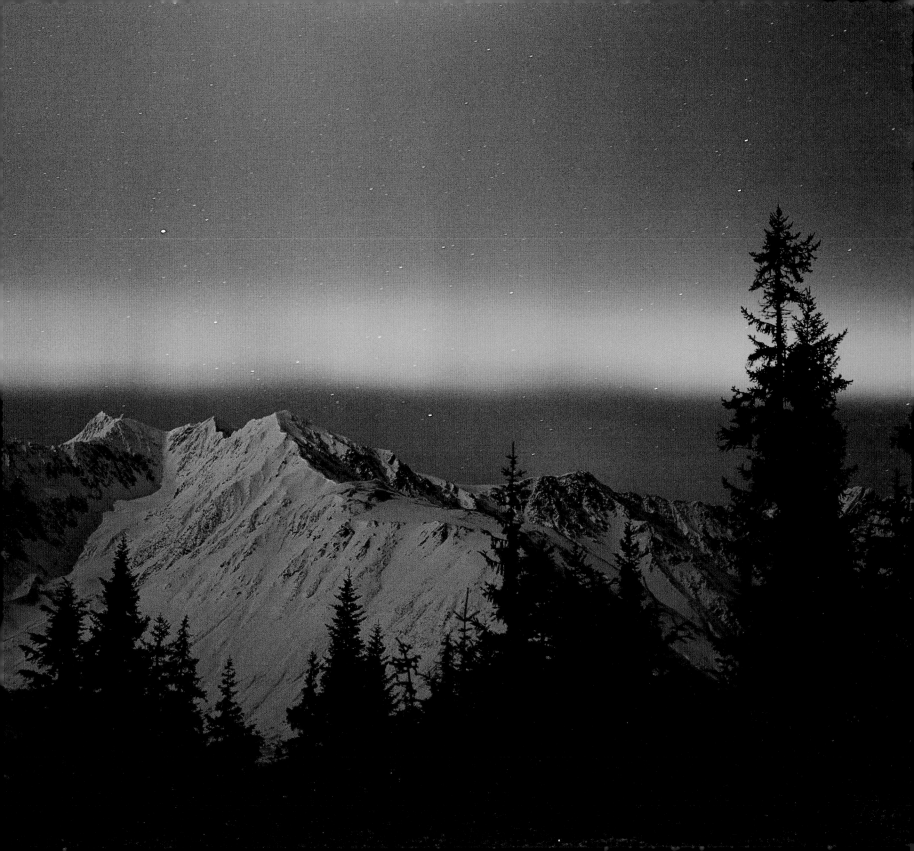

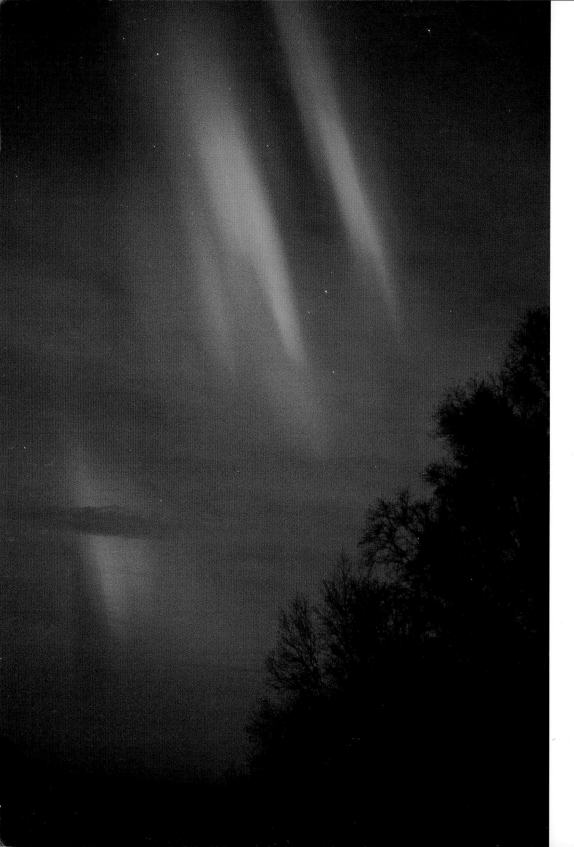

LEFT: *Short parallel arcs appear over Cook Inlet's famous Turnagain Arm (late October).*

RIGHT: *A yellow aurora burns in front of a red aurora, silhouetting an old-growth forest (April).*

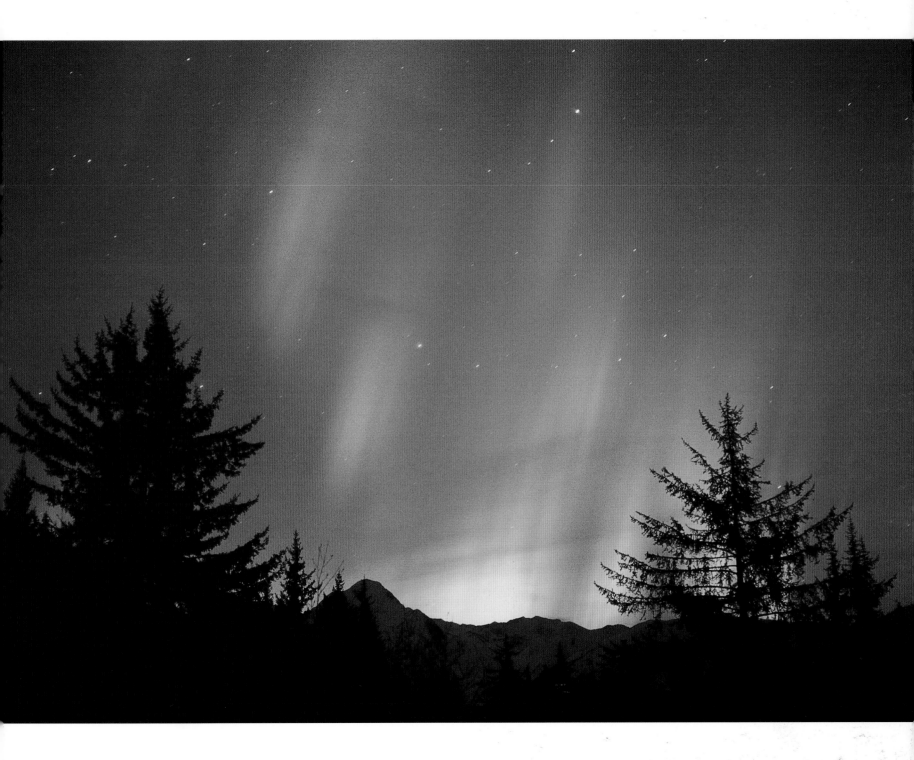

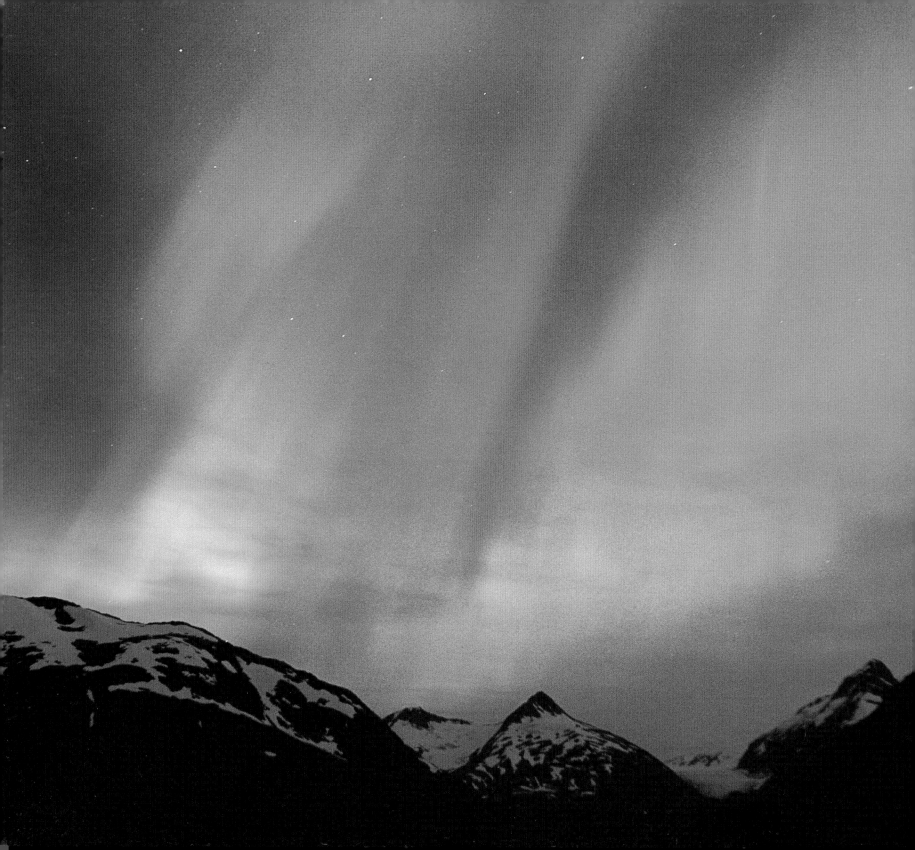

LEFT: *Pyramid-shaped Bard Peak above the Portage Glacier is beautifully crowned with a multi-colored aurora (August).*

RIGHT: *The moonlit Talkeetna Mountains near Palmer anchor some uniquely shaped northern lights (February).*

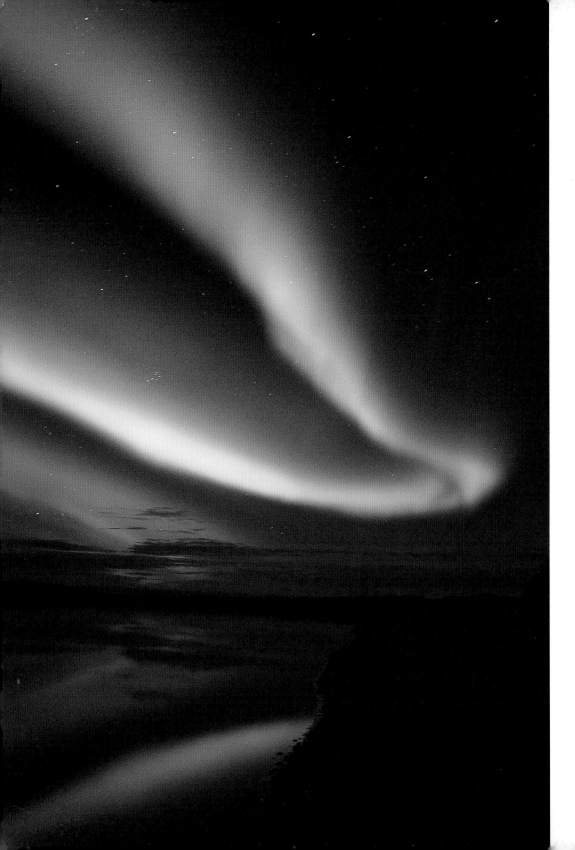

LEFT: *An arc of light circles back creating an unusual shape over the village of Ambler, along the Kobuk River (early September).*

RIGHT: *From a hillside near Flattop Mountain, Anchorage glows under a unique spiral aurora (November).*

FOLLOWING PAGE: *A "night rainbow" reflects on the Twenty-mile River on a peaceful and moonless October night.*

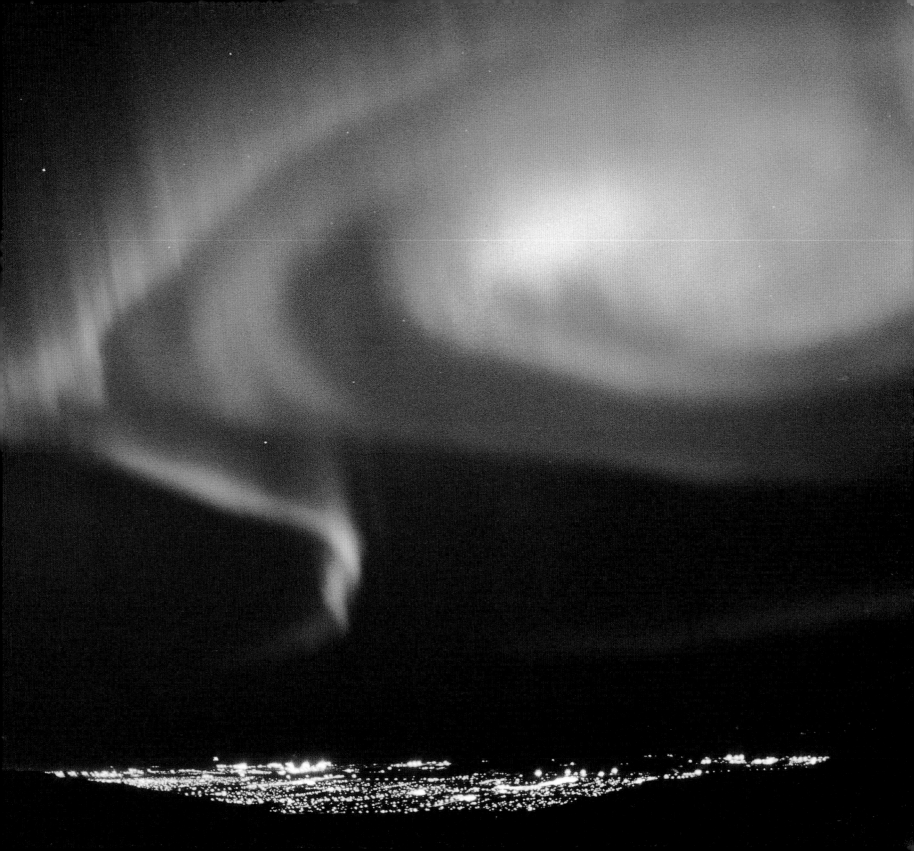

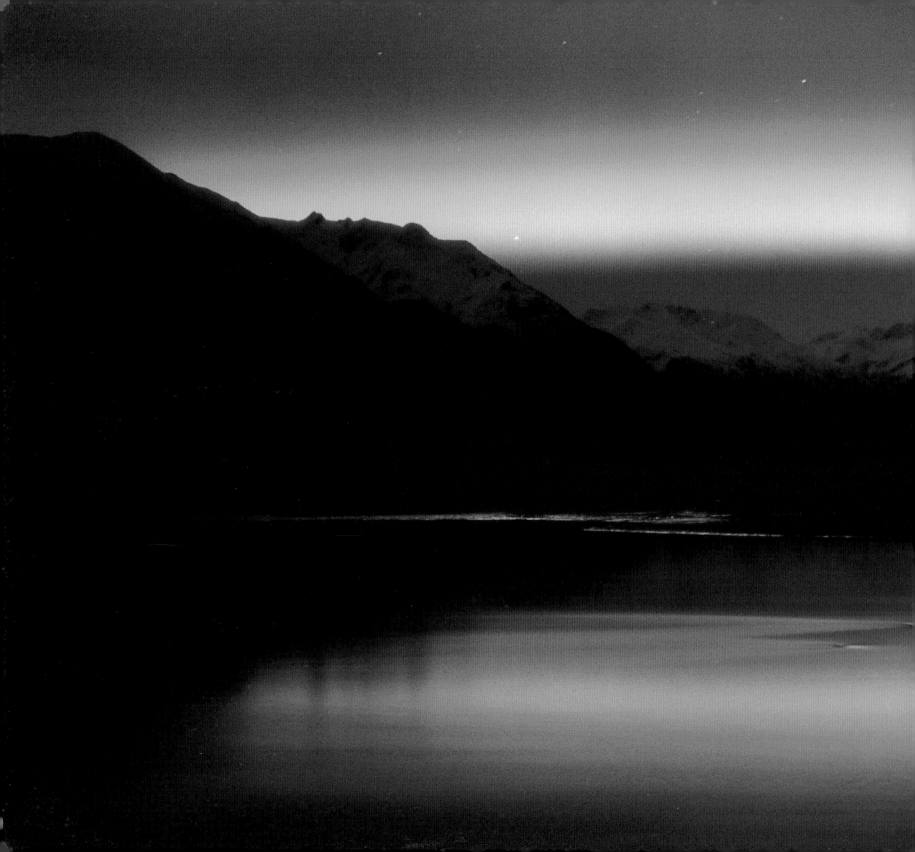

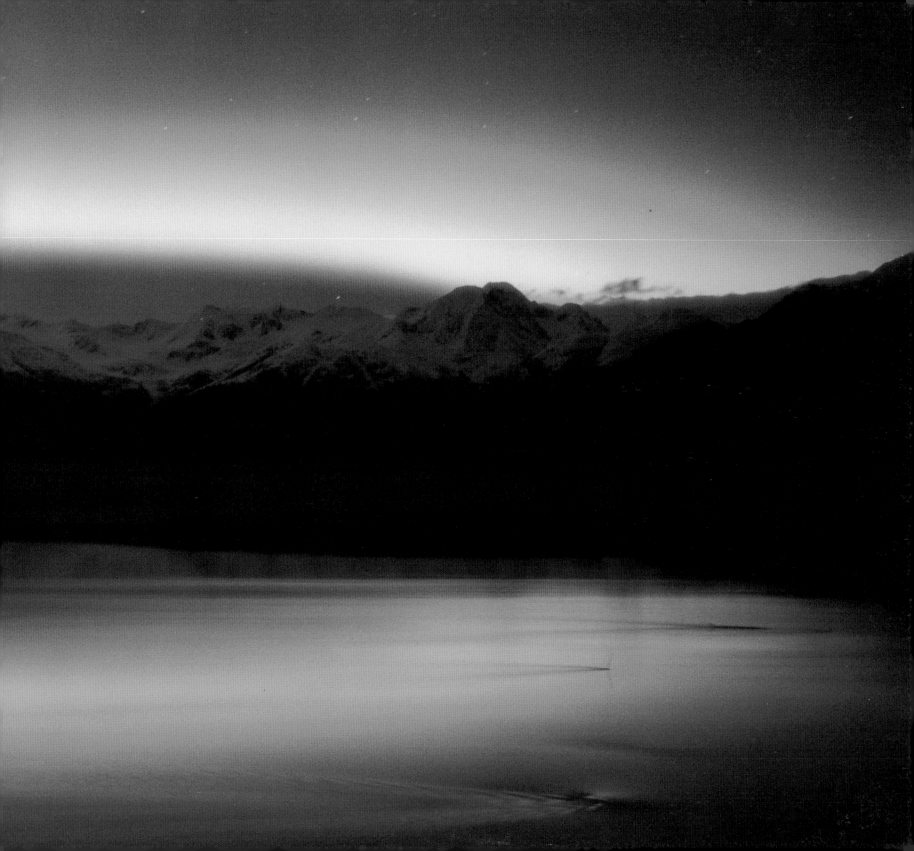

NOTES FROM THE PHOTOGRAPHERS

Growing up in northern Minnesota I had the pleasure of spending much of my time out in the woods. I saw and did things that most modern Americans don't have the opportunity to see or do. I spent countless hours exploring the woods and the swamps and the lakes for wildlife, fish, insects, rocks, and flowers. If there was water, I was probably in it. My mom blamed her gray hair on me and always said that I would either grow webbed feet or drown myself! She could never understand how I kept falling through the ice, even at 20 below zero. (Snow covered springs!)

When I moved to Alaska in 1983 my exploration continued on a grander scale. I had new wildlife to learn about and different terrain. I also started carrying a camera.

Photography enabled me to show people what I was experiencing. In the late eighties I started to try photographing the northern lights. I really didn't have a clue what I was doing but through persistence and luck I managed to get a few good shots. Several people told me that if I would enlarge the pictures, they would buy them. Because of this, the northern lights are a major reason I am now a professional photographer and they are what I am best known for.

The time spent in the field and the traveling I've done have given me the opportunity to experience many things. Snorkeling with humpback whales and dolphins in Maui. Watching wildlife from wolves to moose to grizzly bears. Exploring ice caves in glaciers. Exploring the Grand Canyon, Bryce Canyon, California's redwoods, Yellowstone, Banff, Glacier, and Denali National Parks.

Yet of all the beautiful and amazing things I have seen, the aurora borealis is the most awe inspiring of all! The movement, the power, the patterns, the nuance of colors—I believe they give a glimpse of what heaven will be like. I hope the images in this book help you to share my awe of this most amazing of God's creations! Psalm 19 says it well: "The heavens declare the glory of God: the skies proclaim the work of his hands."

Enjoy!

—CALVIN HALL

The basic premise of photography is putting light on film. Dramatic lighting with vibrant colors, contrast, and motion enhance a photographers ability to create exquisite images. Often occurrences in nature surpass even the most creative imagination. A subject that I have been virtually obsessed with is the northern lights.

Several factors lead to success when photographing the aurora. As in business, location is everything. Living at latitude along the auroral belt will guarantee many chances to capture the perfect picture. For the last decade I have lived in Girdwood, Alaska. It is a small, ski resort community along Cook Inlet's Turnagain Arm, thirty-five miles south of Anchorage. It's an amazingly picturesque setting, and one that has minimal interference from city light, enables quick access to a dark surrounding area, and includes a variety of scenic foregrounds. These elements can prove to be invaluable as forecasts of auroral events are not always accurate and activity can increase without warning.

The magnitude of each display varies with the relative intensity of solar storming. Although it's generally more active around each equinox, the Sun is capable of unleashing its mighty winds at any time. Preparations for the arrival of these winds have been helped tremendously by Internet sites that post continuously updated information on geomagnetic activity.

Lunar cycles also play a role in night photography. The contrast of the northern lights against the sky changes with each phase of the moon. Long exposure times record these differences as being literally as different as night and day. But just as moonlight can be a hindrance for viewing, in moderation it can also illuminate a scene, creating a powerful balance between foreground and sky.

After nearly twenty years of observing and photographing the northern lights, I find only a small percentage of sessions qualify as new images for the "great shot" file. It's the occasional epic show that keeps me chasing

Scientific aspects aside, the northern lights are purely magical.

Through the pictures in this book, those who have never been witness to this phenomenon may appreciate its unparalleled beauty. And from my own collection, these are my best shots.

—DARYL PEDERSON

REFERENCES

BOOKS:

Akasofu, S. I. *Aurora Borealis: The Amazing Northern Lights.* Alaska Geographic, Anchorage, AK, 1979.

Davis, Neil. *The Aurora Watcher's Handbook.* University of Alaska Press, Fairbanks, AK, 1992.

Eather, Robert H. *Majestic Lights: The Aurora in Science, History and the Arts.* American Geophysical Union, Washington, DC, 1980.

Rasmussen, Knud. *Across Arctic America: Narrative of the Fifth Thule Expedition.* University of Alaska Press, Fairbanks, AK, 1999.

Savage, Candace. *Aurora: the Mysterious Northern Lights.* Sierra Club Books, San Francisco, CA, 1994.

ARTICLES:

Akasofu, S. I. "Auroras," *The New Encyclopaedia Britannica*, 15th edition (Macropaedia, vol. 2, pp. 373–377). Chicago, IL, 1975.

Associated Press. "UAF Aurora Forecasts Gaining Accuracy," *Anchorage Daily News,* Dec. 14, 1995.

Brown, Neal. "The Aurora Explained," Geophysical Institute, University of Alaska Fairbanks, posted on www.alaskascience.com.

Cohen, Susan. "Reaching for the Aurora—The Electric Dreams of Ted Stevens," *We Alaskans,* Dec. 15, 1991.

Phillips, Natalie. "Solar Cycles Key to Aurora's Grandeur, Physicists Discover," *Anchorage Daily News,* Nov. 12, 1998.

Rozell, Ned. "Aurora Pioneer Becomes Leader of Arctic Research," *Anchorage Daily News,* July 5, 1999.

————. "If the Light's on, Somebody May be Home," Alaska Science Forum, Geophysical Institute, University of Alaska Fairbanks, May 19, 1999.

————. "Chances of Aurora Interrupting Dinner to Increase," Alaska Science Forum, Geophysical Institute, University of Alaska Fairbanks, Nov. 12, 1998.

————. "Straining to Hear the Voice of the Aurora," Alaska Science Forum, Geophysical Institute, University of Alaska Fairbanks, Oct. 19, 1995.

Senkowsky, Sonya. "Light Show—Aurora Borealis Treats Alaska to Vivid Display," *Anchorage Daily News,* Nov. 12, 1998.

Sullivan, Walter. "Story of Northern Lights Dance Unfolds," *New York Times,* reprinted in the *Anchorage Daily News,* Feb. 16, 1986.

Wohlforth, Charles. "Aurora Man—The Golden Discoveries of Syun-ichi Akasofu," *We Alaskans,* Oct. 19, 1997.

Wright, Karen. "Seeing the Light," *Discover,* July, 2000.

FILM:

The Aurora Explained, by Neal Brown, Claudia Clark, Thomas Hallinan, Mark Linsalata, Lael Morgan; produced by the University of Alaska Fairbanks.

USEFUL WEB SITES:

Alaska's Aurora Forecasts. From the Geophysical Institute at the University of Alaska Fairbanks. www.gi.alaska.edu/cgi-bin/predict.cgi

Calvin Hall's web site: www.alaskasaurora.com

Daryl Pederson's web site: www.alaskaauroraphotos.com

NASA science news. From Marshall Space Flight Center, Huntsville, Alabama. www.science.nasa.gov

Space Weather. Excellent all-around site for aurora and other space weather phenomena. www.spaceweather.com

Today's Space Weather. From the NOAA Space Environment Center in Boulder, Colorado. www.spaceweather.noaa.gov/

Today's Aurora Activity. Animated aurora maps from the NOAA Space Environment Center in Boulder, Colorado. www.sec.noaa.gov/pmap/index.html

BIOGRAPHIES

Calvin W. Hall is a professional photographer located in Anchorage Alaska. His published work has appeared in a number of magazines, including *National Geographic, Discover, Esquire,* and *Alaska,* and has been used by Rand McNally. He does a wide range of photography from scenic, wildlife, stock, commercial, people, macro and panoramic to underwater, (humpback whale, dolphins), but he is best known for his northern lights work (www. alaskasaurora.com).

Daryl Pederson is a photographer from Girdwood, Alaska. Daryl's pictures can be found world-wide in magazines, calendars, cards, and on web sites. While the subjects he shoots are quite diverse, the aurora collection is some of Daryl's finest work (www.alaskaaurora photos.com).

George Bryson writes for the *Anchorage Daily News* and teaches at the University of Alaska, Fairbanks. He lives in the Chugach foothills in southeast Anchorage.

The photographers and author wish to thank the following:
Jo Keller of Keller's Custom Photo Labs, Anchorage; Kate Rogers and the rest of the staff at Sasquatch Books; Charles Mason and the Journalism Department of the University of Alaska Fairbanks; Mike Campbell and the *Anchorage Daily News;* retired professor Neal Brown and the University of Alaska Fairbanks Geophysical Institute; Dr. Syun-ichi Akasofu and the International Arctic Research Center; and the *Alaska Science Forum* reporting by UAF's Ned Rozell.

DEDICATIONS

To my parents, Lee and Pat Hall,
for teaching me the ways of the wilds and giving me the freedom to explore God's amazing creation.
And, for patiently loving me even when that was not an easy thing to do.
—C. H.

For Julie.
—D. P.

To my mother and father, who loved their children and showed them the sky. And for my wife, Ann, and our three
daughters—Kate, Molly, and Rose—for all their support and love.
— G. B.

Published by Sasquatch Books
Distributed by Publishers Group West
Printed in China
10 09 08 07 06 8 7 6 5

Cover and interior design: Karen Schober
Calvin Hall's photographs appear on the following pages: cover, I (frontpiece), 2–3 (title page), 4, 5, 7, 8–9, 10, 12, 13,
15, 16, 18, 19, 20–21, 26, 32–33, 35, 36–37, 38, 42, 43, 44, 47, 48–49, 50, 51, 53, 54, 55, 56–57, 64, 65, 68–69,
•72–73, 75, 76, 78–79, 80, 83, 85, 86–87, 92, 93, 94–95, 98, 100–101, 104, 118, 119, 121.
Daryl Pederson's photographs appear on the following pages: 6, 11, 14, 17, 22, 23, 24, 25, 27, 28–29, 30, 34, 39, 40, 41,
45, 46, 58, 59, 60, 61, 62–63, 66, 67, 70–71, 74, 77, 81, 82, 89, 90, 96, 97, 99, 102, 103, 107, 108, 111, 112,
114–115, 116, 117, 120, 122–23.

Library of Congress Cataloging in Publication Data
Hall, Calvin.
Northern lights : the science, myth, and wonder of aurora borealis / photography by Calvin Hall and Daryl Pederson ;
essay by George Bryson.
p. cm.
Includes bibliography.
ISBN 1-57061-290-0
I. Auroras. I. Pederson, Daryl. II. Bryson, George, 1947– III. Title.

QC972.5.B6 H35 2001
538'.768—dc21

Sasquatch Books
119 South Main Street, Suite 400
Seattle, WA 98104
(206) 467-4300
www.sasquatchbooks.com
custserv@sasquatchbooks.com